Body Painting

all you need to decorate the body beautiful

Sophie Hayes

BODY PAINTING

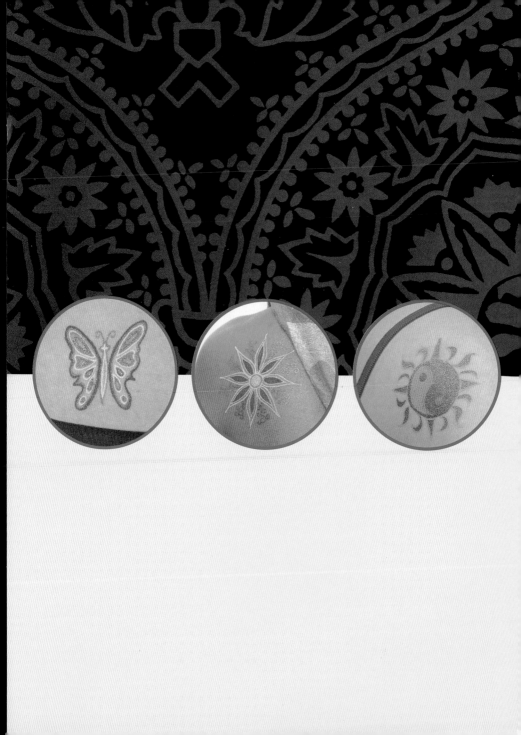

BODY PAINTING

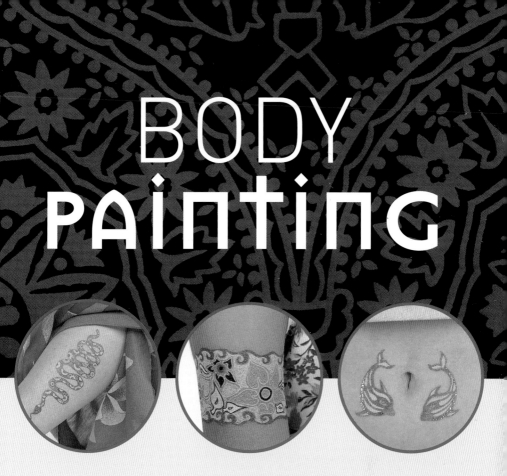

ALL YOU NEED TO DECORATE THE BODY BEAUTIFUL

SOPHIE HAYES

NORTH LIGHT BOOKS

contents

A QUARTO BOOK

Distributed to the trade and art markets in North America by
North Light Books,
an imprint of F&W Publications, Inc.
4700 East Galbraith Road
Cincinnati, OH 45236
(800) 289-0963

Copyright © 2003 Quarto Inc.

ISBN 1-58180-489-X

Conceived, designed, and produced by
Quarto Publishing plc
The Old Brewery

EDITOR: Michelle Pickering
ART EDITOR: Sheila Volpe
ASSISTANT ART DIRECTOR: Penny Cobb
PHOTOGRAPHER: Martin Norris
INDEXER: Dorothy Frame

ART DIRECTOR: Moira Clinch
PUBLISHER: Piers Spence

QUAR.BPK

Manufactured by Universal Graphics
Pte Ltd, Singapore
Printed by Midas Printing Ltd, China

PUBLISHER'S NOTE

The author, publisher, and copyright holder assume no responsibility for any injury or damage caused or sustained while drawing the tattoos described in this book. Always use products that have been dermatologically tested and approved for use on the skin, and seek medical attention should any adverse skin reaction occur.

Pens in kit may differ from those shown in book.

Introduction

THE GLIMPSE OF bare shoulder or swathe of belly revealed by today's fashions are made all the more intriguing when they are decorated, and what better way to paint the body beautiful than with a temporary, designer tattoo? You can use the templates provided in this book to transfer the outlines of the designs directly onto the skin, or follow the instructions for drawing the tattoos freehand. With just a little practice, you'll soon be producing colorful, eye-catching, and trendsetting designs of your own. You can draw the tattoos on some parts of your body yourself, but better still, have a tattoo party with friends and draw them on each other.

Body decoration has been practiced for thousands of years all over the world using many different media, including cosmetics, piercing, and tattoos. Many of these arts date back to the early ages, when people of all societies would decorate themselves to make their own unique statements or to identify themselves as part of a tribe. It is no different today than it was many thousands of years ago.

Ancestral humans experimented with many different plant dyes, such as henna, and had a large selection of colors at their disposal. Modern tattoos are created using many different means, including henna, airbrush art, colored body paints, and tattoo pens. These are all temporary ways to decorate the body, which can be much more appealing than committing to a permanent tattoo.

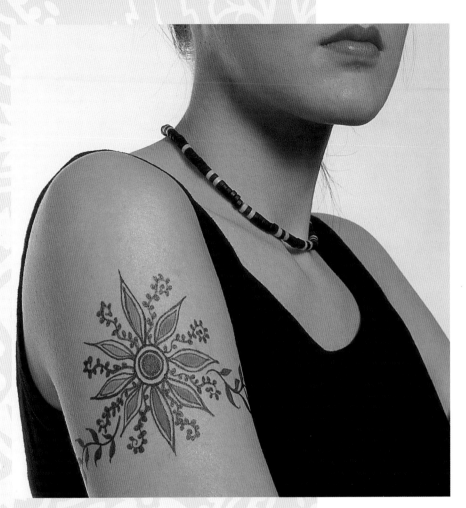

Temporary tattoos provide an instant means of transforming the body into something magical, and are highly effective for wearing to clubs, parties, or special occasions. Whether you use tattoo pens, colored paint, or henna, you will always be able to create a unique and individual statement—and it's great fun, too.

ABOVE This design combines an Indian mendhi flower with vines and leaves.

OPPOSITE A heart decorated with spirals and leaves.

Materials

ONE OF THE GREAT THINGS ABOUT DRAWING YOUR OWN TATTOOS IS THAT YOU NEED VERY FEW MATERIALS TO ACHIEVE SUCCESS. THE MOST IMPORTANT, OF COURSE, ARE THE TATTOO COLORS. TATTOO PENS CONTAINING GEL INK HAVE BEEN USED THROUGHOUT THIS BOOK BECAUSE THEY GLIDE EASILY OVER THE SKIN AND HAVE A FINE NIB THAT ALLOWS YOU TO DRAW INTRICATE DESIGNS. THE PENS CAN BE COMPLEMENTED WITH MAKEUP PENS SUCH AS KOHL, EYE CRAYONS, OR ROUGE. YOU CAN REMOVE THE TATTOOS EASILY WITH SOAP AND WATER OR A CLEANSING WIPE.

Tattoo Pens

Sometimes called tattoo pens, tattoo markers, or tattoo sticks, these are very easy to use and are available in a wide range of pastel, metallic, neon, and glitter colors. When buying pens, make sure they have been dermatologically tested and approved for use on the skin. They should contain water-based, acid-free ink and be washable. Note that nontoxic does not necessarily mean that a pen is safe for use on the skin. Search for them on the Internet if you can't find any in your local stores.

Body Paint

The colors used for body and face painting can also be used to draw tattoos. They are great for coloring large areas, but more difficult for drawing fine lines and intricate designs.

Glitter Gel

Glitter gel is available from face painting suppliers and can be brushed over areas of a design to pick out details and add an extra touch of glamour.

CLEANSING WIPES AND TISSUES

You will need some moist cleansing wipes to clean the skin before drawing your tattoo. You can also use them to wipe away any mistakes you make and to remove the tattoo when you no longer want it. Have a box of tissues at hand to dry the skin after it has been cleansed.

COTTON SWABS

Cotton swabs are ideal for correcting small mistakes. Moisten them with a cleansing wipe first.

TALCUM POWDER AND COTTON BALLS

Dabbing talcum powder onto a finished tattoo with a cotton ball will help to protect it. The powder will soak into the ink and prevent it from smudging as easily.

PETROLEUM JELLY

Applying petroleum jelly or hair wax to the design before you take a bath or shower will protect it from the water.

TRACING PAPER

You will need thin tracing paper or fine tissue paper to trace the templates in this book if you wish to use the transfer drawing technique.

ANTISEPTIC WIPES

Use an alcohol-based cleansing wipe to moisten the skin before applying a transfer design. These are also ideal for removing tattoos, especially if you have protected them with petroleum jelly or have used pens containing metallic ink, which can be a little harder to remove with soap and water.

SKIN TEST

Before using any product on the skin, it is sensible to test it on a small area first. Even if a tattoo pen has been approved for use on the skin by the manufacturer, people with sensitive skins may have a reaction to the inks. To check that your skin accepts the pens, try a patch test first. Draw small dots of each of the colors onto your arm. Check them after 24 hours. If there is any swelling or redness, wipe the ink away with an antiseptic wipe and seek medical attention if necessary. Never draw a tattoo on broken areas of skin.

Drawing Techniques

TWO BASIC TECHNIQUES—DOT AND TRANSFER—HOLD THE KEY TO PRODUCING SUCCESSFUL TATTOOS. THE DOT METHOD INVOLVES ROUGHING OUT THE BASIC SHAPE OF THE TATTOO BY DRAWING SMALL DOTS AT KEY POINTS OF THE DESIGN, THEN JOINING UP THE DOTS WITH A SMOOTH LINE. THE TRANSFER METHOD INVOLVES TRACING A TEMPLATE AND APPLYING THE TRACING DIRECTLY TO THE SKIN. INSTRUCTIONS ARE GIVEN FOR DRAWING EACH OF THE KEY ELEMENTS USING THE DOT METHOD, WHILE A TEMPLATE OF THE DESIGN IS ALSO PROVIDED, ENABLING YOU TO USE THE TRANSFER TECHNIQUE AS AN ALTERNATIVE. SIMPLY CHOOSE WHICHEVER METHOD SUITS YOU BEST.

CLEANSING THE SKIN

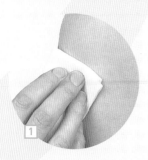

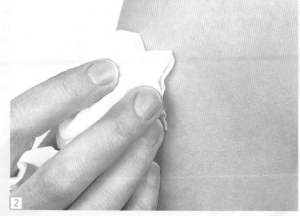

1 It is important that the skin is clean before you draw your design, so use a moist cleansing wipe to remove any dirt or sunscreen.

2 Dry the area thoroughly with a tissue after it has been cleansed.

DOT METHOD

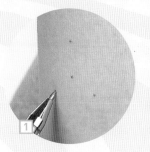

1 Decide where you are going to position your design and draw a small dot to mark the center point. Next, draw the first few key points of the design. In this example, the key points are the north, southeast, and southwest points of a triangle. The distance of these points from the center dot will determine the size of the triangle.

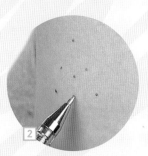

2 Place another dot midway between each of the three key points.

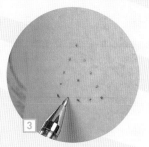

3 Draw additional dots between these ones until you feel confident about the shape you have created.

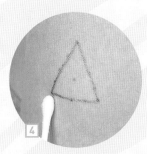

4 Join the dots as smoothly as possible with a line of color. If you make a mistake, use a cleansing wipe or moistened cotton swab to wipe it away, taking care that you don't smudge your design.

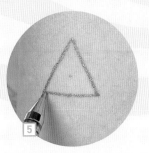

5 Draw over the line once again until it is smooth and even.

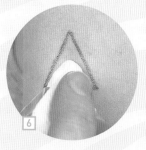

6 Wipe away the center dot when you are satisfied with the finished design.

TIP When drawing a design onto the skin, you will be holding the pen horizontally rather than vertically, so if it feels like the ink is running out, stop and tilt the pen to an upright position for a few seconds and then start again.

TRANSFER METHOD

1 Trace the design onto thin tracing paper or tissue paper using a tattoo pen. If you are drawing a complicated design, it is best just to trace the main outline and then fill in the decoration freehand or using the dot method afterward.

2 Dab an antiseptic wipe onto the area where the design is to go. Make sure you apply enough to cover the area, but not so much that it becomes too sticky.

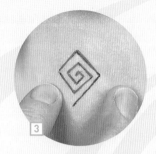

3 Place the traced design face down onto the sticky area of skin and press firmly. You need to do these first three stages fairly quickly so that the tracing and the skin are still damp.

4 Gently pull away the paper. Your design is now lightly transferred onto the skin. Notice that the result is a mirror image of how the template appears on the printed page.

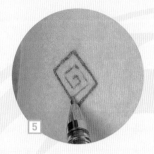

5 Carefully draw over the transferred lines of the design to get strong, smooth lines of color.

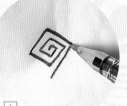

6 If you want the design to face in the same direction as it does on the page, you need to turn the tracing paper over and draw over the lines of the design on this side of the paper. The only tattoos in this book where you must use this stage are the yin/yang and Japanese calligraphy designs, because it is important that these face in the right direction.

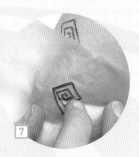
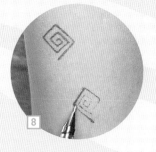

7 Apply this side of the paper face down on the skin and press firmly. Remember to use an antiseptic wipe to dampen the skin first.

8 Draw over the lines of the design to strengthen them. Notice that the design now faces the same way as it does on the printed page.

PROTECTING THE TATTOO

1 Use a cotton ball to dab some talcum powder onto your design to help stop it from smudging. Using a clean cotton ball, keep pressing firmly onto the design to remove the excess powder. You need to press fairly strongly, but take care that you don't smear the design.

2 Use a finger to dab some petroleum jelly or hair wax onto the design before you take a bath or shower.

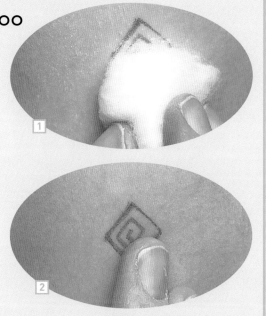

KEY
ELEMENTS

THIS CHAPTER CONTAINS THE
20 KEY ELEMENTS THAT ARE USED TO
BUILD UP THE MORE COMPLEX TATTOO DESIGNS
IN THE FOLLOWING CHAPTER. EACH OF THE
ELEMENTS IS EXPLAINED STEP BY STEP, SO ONCE YOU
HAVE MASTERED HOW TO DRAW THEM, YOU WILL FIND
IT EASY TO CONSTRUCT THE MORE COMPLICATED
DESIGNS. THERE ARE ALSO TEMPLATES THAT
YOU CAN TRACE. REMEMBER TO CLEANSE
AND DRY THE SKIN BEFORE
DRAWING THE TATTOOS.

Circles and Ovals

THE CIRCLE FEATURES IN MANY OF THE DESIGNS IN THIS BOOK, SO IT IS IMPORTANT THAT YOU LEARN TO DRAW IT WELL. IT IS A SIMPLE ELEMENT BUT CAN BE DIFFICULT TO DRAW, SO IT IS BEST TO DOT OUT THE SHAPE OF THE CIRCLE FIRST BEFORE DRAWING THE OUTLINE. YOU CAN THEN ADD OTHER DESIGN ELEMENTS TO CREATE BEAUTIFUL MOTIFS SUCH AS SUNS, MOONS, AND FLOWERS. YOU CAN ALSO ADAPT IT INTO AN OVAL SHAPE. PRACTICE ON PAPER FIRST—THE MORE YOU PRACTICE, THE EASIER IT WILL BECOME TO DRAW A GREAT CIRCLE EVERY TIME.

CIRCLE

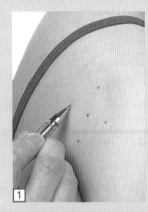

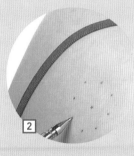

2 Place another dot midway between each of the existing dots.

3 You now have a complete circle, ready to join up. If you feel nervous about joining the dots smoothly, however, you can add more dots between each pair of existing ones.

1 Draw a dot to mark the center of the circle. Draw four more dots to the north, south, east, and west of it, placing them as far from the center point as you want the circle to run.

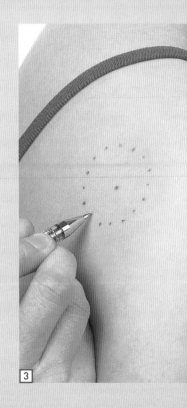

4 Once you are happy with the shape, join the dots together to form a circle, then draw over the circle once again to smooth it out. Wipe away the central dot if this area will remain visible.

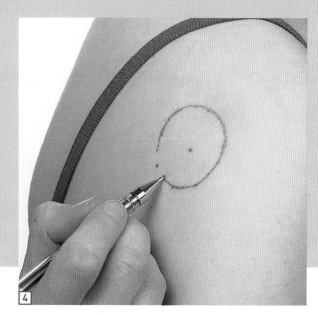

OVAL

2 Draw as many dots between them as you need to give a good guide, then smoothly draw over them, as before.

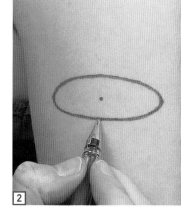

1 Use exactly the same technique as for drawing a circle but space the north/south or east/west points farther out from the central dot.

Yin/yang Symbol

THIS ELEMENT REPRESENTS THE UNION AND BALANCE OF OPPOSITES AND IS UNIVERSALLY POPULAR. IT SYMBOLIZES THE MOVEMENT OF CREATION THROUGH TIME AND SPACE AND IS CHINESE IN ORIGIN. THE SYMBOL IS FAIRLY SIMPLE TO DRAW—ALL YOU NEED ARE THREE CIRCLES AND AN S SHAPE. IT CAN BE INCORPORATED INTO MANY OTHER TATTOO DESIGNS AND YOU CAN ADD CURLS, LEAVES, FLOWERS, OR GEOMETRIC SHAPES AS DECORATION. THE TWO SIDES OF THE SYMBOL ARE USUALLY BLACK (YIN) AND WHITE (YANG), BUT YOU CAN CHOOSE OTHER COLORS IF YOU WISH.

1 Draw a circle (see pages 16–17), leaving the center dot visible. Place your pen on the circumference of the circle slightly to the left of the north point. Carefully draw a curve down to the center dot of the circle.

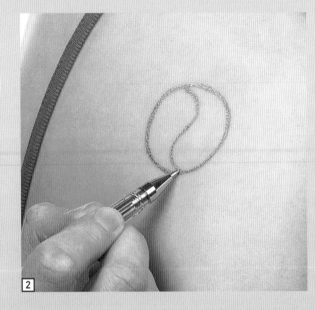

2 Continue drawing a curve from the center dot down to the bottom edge of the circle, finishing slightly to the right of the south point. The completed curve should look like a backward S shape.

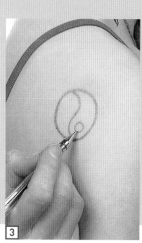

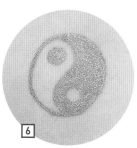

3 Draw a small circle within each curve of the S shape. You can draw them freehand or use the dot technique as before.

5 Fill the top left circle and the right side of the symbol with one color.

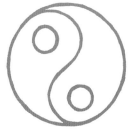

6 Leave the remaining circle and the left side of the symbol empty, or fill them with a second color.

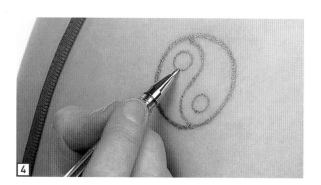

4 Don't make the circles too small because, when you fill one side of the symbol with a dark color, the light-colored circle within it will appear to shrink.

Sunshine Rays

SUNSHINE RAYS CAN BE ADDED TO MANY OF THE KEY ELEMENTS, SUCH AS THE YIN/YANG SYMBOL, AND ARE EFFECTIVE AS ARM, ANKLE, AND ESPECIALLY BELLY BUTTON DESIGNS. A SUN DECORATED WITH A SMILING FACE IS A VERY POPULAR MOTIF. TWO TYPES OF RAYS ARE SHOWN HERE—STRAIGHT AND CURVED. THEY LOOK GOOD WHEN USED SEPARATELY, OR YOU CAN ALTERNATE BETWEEN THEM FOR A MORE FLAMBOYANT DESIGN. YOU CAN HAVE AS MANY RAYS AS YOU WANT, DEPENDING ON THE SIZE OF THE CIRCLE, BUT EIGHT IS A GOOD NUMBER TO START WITH.

Straight Rays

1 Draw a circle (see pages 16–17), making sure it is large enough to accommodate a face or other form of decoration if necessary.

2 Draw a dot to the north, south, east, and west of the circle to mark the tips of the first four rays.

3 Draw dots for the outline of each ray, making the lines as straight as you can. Draw over the lines of dots for each ray. Start at the circle and draw outward to the end point and then back inward to the circle again.

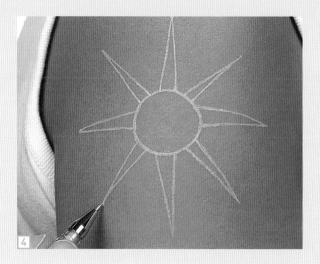

4 Use the same technique to draw another ray midway between each of the existing four rays. If necessary, draw over the lines a second time to smooth them out.

CURVED RAYS

1 Draw curved rays in the same way as straight ones, but draw the lines of dots in S-shaped curves rather than straight. If you make a mistake, wipe away the dots and start again.

2 Draw over the lines of the rays a second time to smooth them out if the dots remain visible.

Mɛnꝺнı Flowɛʀ

MENDHI ARE TRADITIONAL INDIAN DESIGNS THAT ARE APPLIED TO THE SKIN USING HENNA PASTE, A NATURAL PLANT DYE THAT STAINS THE SKIN A DEEP BROWN COLOR. TRADITIONALLY, A BRIDE'S HANDS AND FEET ARE PAINTED WITH FLOWER, PAISLEY, AND OTHER ORGANIC DESIGNS BEFORE HER WEDDING DAY. THE FLOWER MOTIF SHOWN HERE IS A VERY POPULAR EXAMPLE AND IS IDEAL AS AN ARM, BELLY BUTTON, OR SHOULDER TATTOO. THE FLOWER IS COMPOSED OF TWO CENTRAL CIRCLES, FROM WHICH EIGHT PETALS RADIATE OUTWARD.

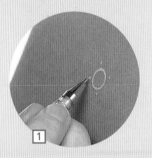

1 Draw a small circle (see pages 16–17), then draw four more dots around the outside of this circle in the north, south, east, and west positions. The distance of the dots from the first circle will dictate the size of the second circle.

2 Add more dots between the four points if you need to, then smoothly join them up to form the second circle.

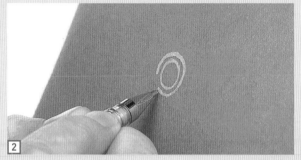

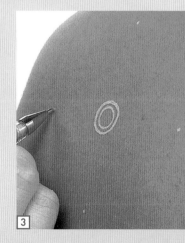

3 Draw a dot to the north, south, east, and west of the outer circle to mark the tips of the first four petals. Make the petals as long you wish.

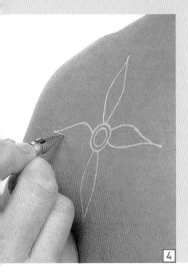

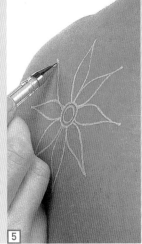

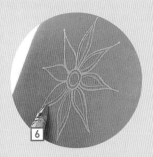

6 Use the same technique to add an inner petal to each of the eight outer ones.

4 Carefully draw each petal, starting at the outer circle and working in a smooth curve out to the tip of the petal and then back to the circle again. Draw them freehand or dot out the shapes of the petals first.

5 Now draw dots to mark the tips of four more petals midway between the existing ones. You can make them the same length or slightly smaller. Again, either draw the petals freehand or dot them out first.

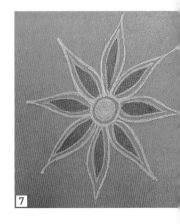

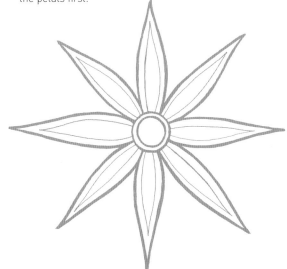

7 Color the flower as you wish. Filling the inner petals with one color and the inner circle with another color is a good combination.

Vines and Tendrils

TENDRILS OF VINES, LEAVES, AND FLOWERS ARE COMMONLY USED AS ARMBANDS BUT CAN ALSO ENCIRCLE THE ANKLE, WRIST, OR BELLY BUTTON.

THE EXAMPLE SHOWN HERE HAS LEAVES AT EACH END AND SMALL SHOOTS OF BERRIES AT REGULAR INTERVALS ALONG THE TENDRIL. ALTERNATELY, YOU COULD REPLACE THE BERRIES WITH SMALL FLOWERS. THE IMPORTANT THING TO LEARN WHEN PRACTICING THIS ELEMENT IS HOW TO DRAW THE TENDRIL SYMMETRICALLY AND AT AN EVEN LEVEL AROUND THE ARM OR OTHER BODY PART.

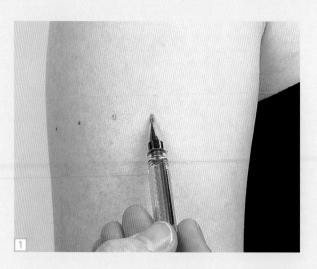

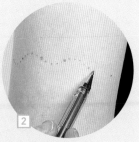

1 It is important to dot out a straight line first or the design will be slanted and look wrong. Place a dot in the center where you want to draw the tendril. Starting at this point, draw a line of dots outward in both directions as straight as you can. If the tendril is going to be an armband, you don't need to draw your design all the way underneath because it will only get smudged and that area will not be seen anyway.

2 Draw a curving line of dots, passing above and below the straight line evenly. Wipe away any mistakes and start again if you need to.

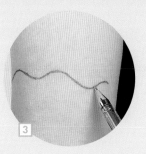

3 Smoothly join up the curved line of dots. Draw over the line a second time to smooth it out.

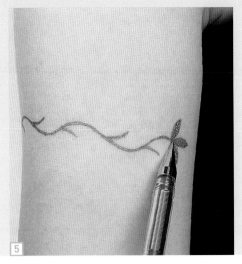

5 You can decorate your tendril in any way you wish. Here, we have added three leaves at each end (see page 27).

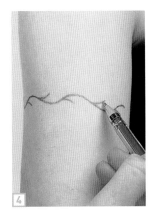

4 Draw some smaller tendrils coming out from the main one. Make sure you place your pen on the main tendril and draw outward from there so that you don't risk spoiling the smoothness of the line.

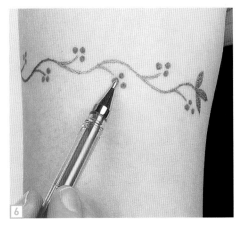

6 Draw three dots at the end of each smaller tendril to represent berries or choose an alternative design such as a flower.

CURLS AND LEAVES

NATURAL, ORGANIC MOTIFS SUCH AS CURLS AND LEAVES ARE EXTREMELY VERSATILE AND CAN BE INCORPORATED INTO MANY OF THE DESIGNS IN THIS BOOK. FOR EXAMPLE, AN ELEMENT SUCH AS PAISLEY CAN BE ENLIVENED DRAMATICALLY BY SURROUNDING IT WITH CURLS AND LEAVES. YOU CAN ALSO DRAW A LONGER STEM OF CURLS AND LEAVES AROUND AN ANKLE OR WRIST FOR A SIMPLE BUT ATTRACTIVE TATTOO, OR USE IT AS A SHOULDER MOTIF. THERE IS NO LIMIT TO WHAT YOU CAN CREATE WITH THESE SIMPLE BUT DECORATIVE ELEMENTS.

CURL

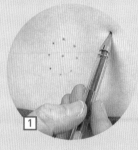

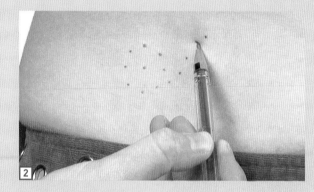

1 Dot out the shape of a circle but don't join up the dots yet (see pages 16–17). Place a dot where you want the straight end of the curl to finish.

2 Place your pen on the circumference of the circle and draw a curving line of dots from the circle to the end point.

3 When you are happy with the shape, smoothly join up the dots. Wipe away any remaining dots from the original circle you drew.

4 To create a thick curl, draw a second line of dots parallel to the first one, then join them into a smooth curve.

LEAF

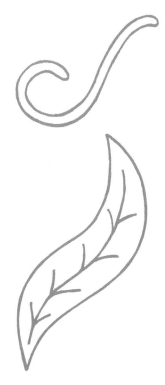

1 Draw a dot where you want each end of the leaf to be, then draw two lines of dots between the two end points. You can create many different shapes. Join the dots together when you are happy with the result.

2 You can draw veins inside the leaf if you like. Start by dotting out the central line, then join up the dots. Draw smaller veins coming out from the central line wherever you wish.

stem

1 Place a dot in the center where you want to draw the stem. Starting at this point, draw a line of dots outward in both directions to act as a guideline.

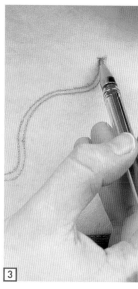

3 Draw another wavy line roughly parallel to the first and join the ends to form a stem.

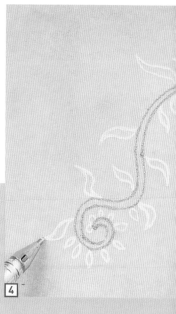

4 Draw some leaves radiating out from the stem, leaving gaps between them for some curls. Make the leaves smaller around the tip of the stem.

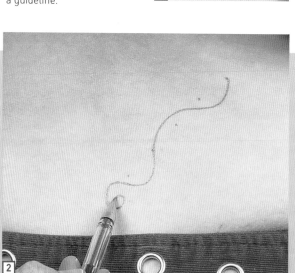

2 Draw a curving line of dots, passing above and below the straight line in a shape you like. Smoothly join up the curved line of dots, then wipe away any remaining guide dots.

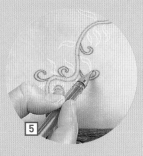

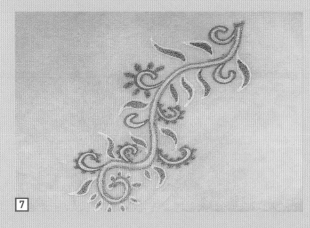

5 Now add some curls between the leaves. You can vary the size of the curls if you wish.

7 Color the finished stem in any color combination you like. Shades of green and bright floral colors work well with this design.

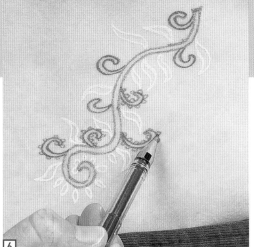

6 For variety, try adding tiny leaves around the outside of some of the curls.

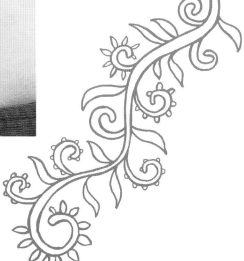

Retro Flowers

DESIGNS FROM THE 1960s WORK VERY WELL AS TATTOOS. THESE FLOWERS WERE INSPIRED BY THE FASHION DESIGNER MARY QUANT, WHO WAS FAMOUS FOR A DAISY MOTIF THAT SHE USED ON CLOTHING, MAKEUP, AND JEWELRY. TWO DIFFERENT FLOWERS ARE SHOWN HERE, BUT YOU CAN USE ANY COMBINATION OF PETALS, STEMS, AND LEAVES THAT YOU WISH. PRACTICE DRAWING THEM ON PAPER AND SEE HOW MANY RETRO DESIGNS YOU CAN COME UP WITH. TRY USING LOTS OF DIFFERENT COLORS TO CREATE A REALLY PSYCHEDELIC LOOK.

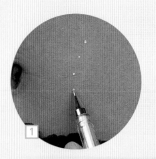

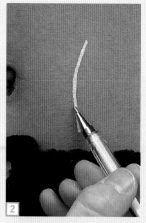

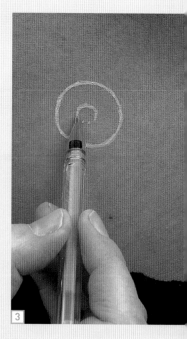

1 Starting with the larger daisy, draw a dot to mark the top and bottom of the stem. Add more dots in a slightly curving line between the first two.

2 Join up the dots of the stem with a thick line.

3 Draw a medium-sized circle above the stem for the flower and a smaller circle within it (see pages 16–17).

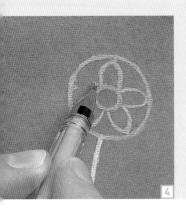

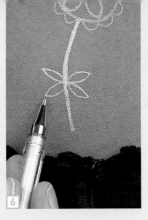

6 Add four leaves halfway up the stem. Draw them freehand or dot out the shapes first.

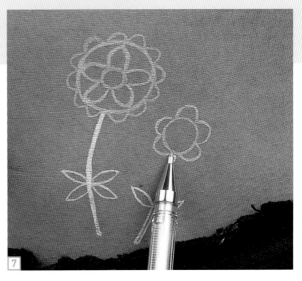

4 Draw five dots equidistant around the outer circle, then draw the five inner petals so that their tips touch the five dots you have just drawn. Dot out the shapes of the petals first if you don't feel confident drawing them freehand.

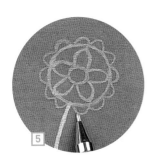

7 Use the same method to draw the smaller flower, varying the number and position of the petals and leaves as shown.

5 Now add the twelve smaller petals around the outer circle.

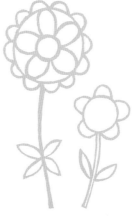

Mackintosh Rose

CHARLES RENNIE MACKINTOSH WAS AN INFLUENTIAL DESIGNER FROM THE
EARLY 1900s WHO CREATED PAINTINGS, TEXTILES, AND INTERIORS. THIS ROSE
DESIGN WAS INSPIRED BY ONE OF HIS MOST DISTINCTIVE
MOTIFS, WHICH MACKINTOSH USED ON WALLPAPER, JEWELRY,
POSTERS, AND INTERIORS. IT HAS BOLD LINES THAT ARE EASY
TO DRAW IF YOU START FROM THE CENTER OF THE ROSE AND WORK OUTWARD.
ADD A STEM AND A COUPLE OF LEAVES AND USE IT AS AN ANKLE OR SHOULDER
MOTIF, OR USE THE ROSES TO ADORN TENDRILS OF FOLIAGE AS AN ARMBAND.

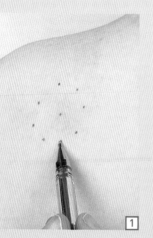

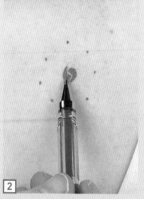

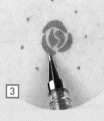

3 Draw three more curved shapes around the two central ones and fill these with color. You can use the same color for the whole rose or combinations of different shades.

1 Dot out the shape of a circle but don't join up the dots or wipe away the central dot (see pages 16–17). This circle will act as a guideline for the circumference of the rose.

2 Draw a couple of small curved shapes around the central dot of the rose and fill them with color.

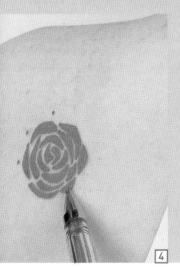

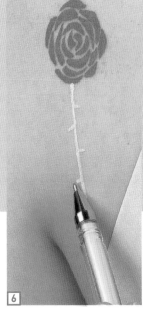

6 Draw a line of dots below the rose, then join up the dots to form a stem. Add a few small thorns along the stem.

4 Continue drawing curved shapes around the central ones until you reach the circumference of the circle.

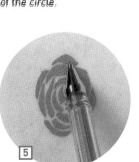

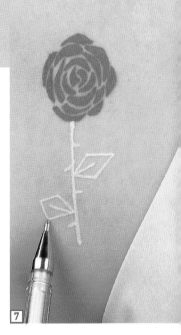

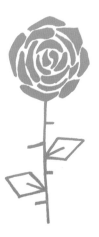

5 Either incorporate the circle of guide dots into the outermost curves of the rose or wipe them away.

7 Draw a single leaf on each side of the stem (see page 27). Angular-shaped leaves work very well with this rose.

Mystical Eye

THE MYSTICAL EYE MOTIF DERIVES FROM ANCIENT EGYPT, WHERE IT WAS ALSO CALLED THE EYE OF THE HAWK OR THE EYE OF HORUS. IT IS CONSIDERED TO BE PROTECTIVE TO THE WEARER AND CAN BE DRAWN LOOKING TO THE RIGHT OR LEFT, THE LEFT BEING THE MALE SYMBOL AND THE RIGHT THE FEMALE SYMBOL. WEAR THEM BOTH TOGETHER AND YOU WILL HAVE THE ULTIMATE PROTECTION. YOU CAN INCORPORATE THE EYE INTO OTHER DESIGNS OR USE IT ON ITS OWN. IT LOOKS GREAT WHEN SHADED WITH RICH, OPULENT COLORS.

2 Draw curving lines of dots to form the outer lines of the eye, then carefully join up the dots. It takes practice to get a perfect eye shape, so wipe the dots away and start again if you need to.

1 Draw a dot where you want the center of the eye to be. Draw two more dots for the top and bottom of the eye and two dots for the corners of the eye.

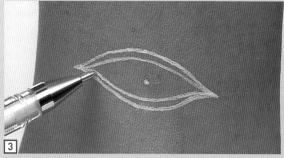

3 Repeat this process to draw curving lines just inside the outer lines of the eyes.

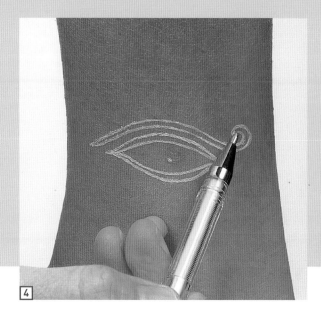

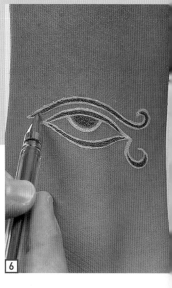

4 Dot out and draw a pair of lines above the eye to form the eyebrow. Follow the curve of the eye shape and draw as neatly as possible. Add a curl at the outer end of the eyebrow (see pages 26–27). It can be as large or as small as you wish.

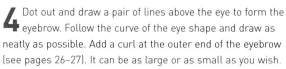

5 Dot out a half circle for the iris of the eye, then draw over the line of dots. Using a different color, dot out another half circle inside the iris to form the pupil and fill it with color.

6 Add another curl at the outer corner of the eye. Fill the outline of the eye and the eyebrow with your chosen color.

Snake

THE SNAKE IS EASIER TO DRAW THAN IT LOOKS BECAUSE IT DOES NOT HAVE TO BE PERFECTLY SYMMETRICAL. IT STARTS AT THE TAIL AND GOES DOWN TO THE HEAD, SO IT WOULD BE SUITABLE AS A BACK TATTOO, WITH THE TAIL OF THE SNAKE STARTING AT THE NAPE OF THE NECK. YOU CAN ALSO CURL THE SNAKE AROUND THE BODY IN ALL SORTS OF AREAS—AROUND AN ARM, AN ANKLE, OR RUNNING DOWN A LEG. SIMPLY MAKE THE DESIGN LARGER OR SMALLER BY CHANGING THE SIZE AND NUMBER OF BENDS IN THE SNAKE'S BODY.

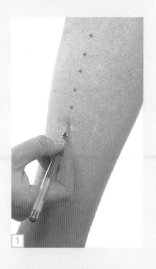

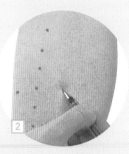

2 Draw two equidistant dots out from the center line halfway down the snake. These indicate the widest part of the snake's body.

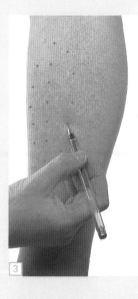

1 Draw a pair of dots to mark the top and bottom of the snake. Draw a straight line of dots all the way down from the top to the bottom.

3 Now dot various positions for each curve of the body all the way down the design. This will provide a rough guide for where the S bends will be.

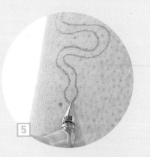

5 When you feel confident that the shape is good, carefully join the dots with two continuous lines. Start at the tip of the tail and work down to the head for each line of the snake.

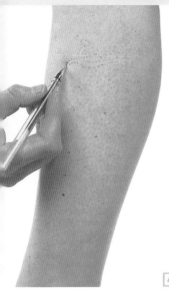

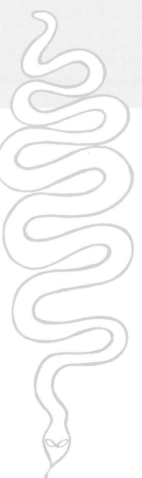

4 Dot out the shape, drawing parallel curving lines of dots to form the thickness of the snake's body. Make sure that the lines do not overlap anywhere and make the bends in the body as smooth as you can. Position the larger bends in the middle of the snake and taper off to smaller bends near the head and tail.

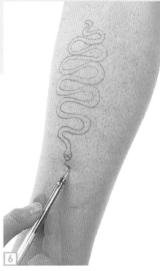

6 Draw a pair of slanted eyes and a curling or forked tongue.

Spirals

SPIRALS ARE EXTREMELY USEFUL ELEMENTS. YOU CAN DRAW LOTS OF SPIRALS INSIDE LARGER MOTIFS TO CREATE AN ATTRACTIVE PATTERN OR ADD THEM TO THE OUTLINES OF THE ELEMENTS FOR DECORATION. THE TWO BASIC SPIRALS ARE CIRCULAR AND S SHAPED, AND AS WELL AS BEING USEFUL ORNAMENTATION FOR OTHER DESIGNS, THEY CAN ALSO BE COMBINED ON THEIR OWN TO CREATE AN ATTRACTIVE ARM OR ANKLE BAND. YOU CAN DRAW THE SPIRALS FREEHAND OR DOT OUT THE SHAPES FIRST IF YOU WANT THEM TO BE PERFECTLY SYMMETRICAL.

CIRCULAR SPIRAL

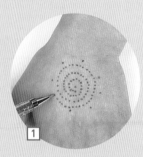

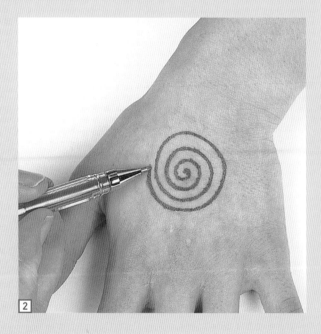

1 Dot out the shape of a circle but don't join up the dots yet (see pages 16–17). Starting at the center of the circle and working out toward the circumference, dot out a circular spiral shape.

2 When you are happy with the spiral, smoothly join up the dots, leaving a section of the outer circle open where the spiral ends. Wipe away any remaining dots.

S-SHAPED SPIRAL

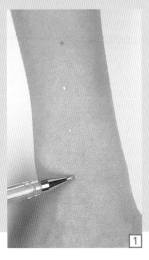

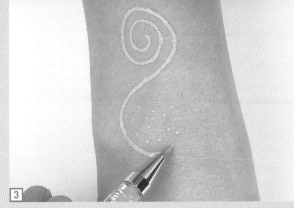

3 Extend each end of the S shape into a spiral, dotting out the curves first if you need to.

1 Draw three dots in a vertical line to mark the top, middle, and bottom of the spiral.

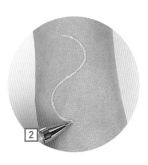

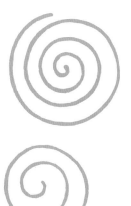

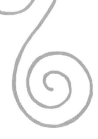

2 Dot out the curves of an S shape, using the first three dots as a guideline. You can draw either a forward- or a backward-facing S. Smoothly join up the dots.

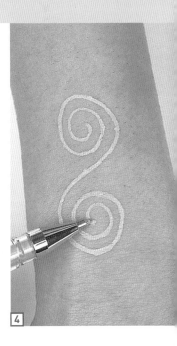

4 If necessary, draw over the line a second time to smooth it out.

SPIRAL BAND

1 Draw a central dot where you want the band to be. Starting at this point, draw a line of dots outward in both directions as straight as you can. This will provide a guideline to help you get the curves of the band as symmetrical as possible.

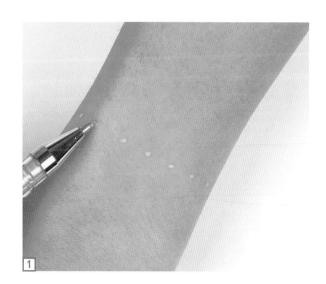

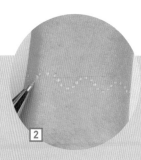

2 Draw a curving line of dots, passing above and below the straight line evenly. Wipe away any mistakes and start again if you need to.

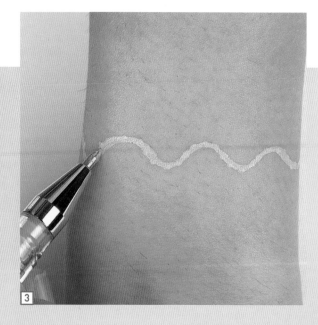

3 Smoothly join up the curved line of dots. Draw over the line a second time to smooth it out if necessary.

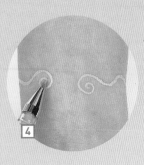

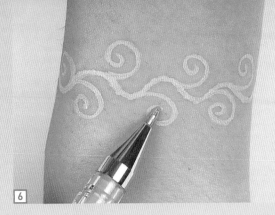

4 Draw a spiral at each end of the band, dotting out the shape first if you wish. Try to make them the same size and shape so that the design looks balanced.

6 Draw a spiral at each of the remaining curves along the band. You can vary their sizes and shapes if you like, but it may be harder to achieve a balanced design if you do so.

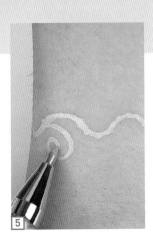

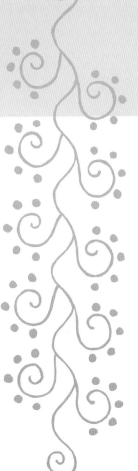

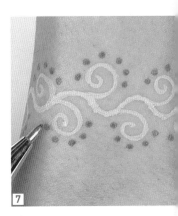

5 Place your pen at the center of the first curve of the band and draw a smooth spiral out from the curve. You can dot out the shape if you like before drawing the line.

7 You can embellish the spirals with small dots of a second color or another design that you like.

Paisley

PAISLEY IS AN INDIAN MOTIF THAT IS OFTEN FOUND ON TEXTILES. IT FORMS THE BASIS FOR MANY OF THE DESIGNS IN THIS BOOK, INCLUDING A DELICATE MOTIF SUITABLE FOR DECORATING THE WRIST AS WELL AS SOME LARGER DESIGNS. ITS FLOWING, ORGANIC SHAPE CAN BE TRANSFORMED INTO MANY VARIATIONS, INCLUDING PEACOCKS AND FISH, AND THE INSIDE OF THE PAISLEY CAN BE FILLED WITH ANY DECORATIVE DESIGN THAT YOU WISH. THE CORE OF THE PAISLEY DESIGN STARTS AS A SIMPLE CIRCLE, SO IT IS EASIER TO DRAW THAN YOU MIGHT THINK.

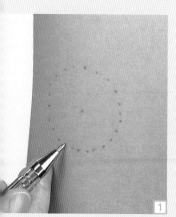

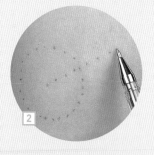

1 Dot out a circle (see pages 16–17). This forms the main body of the paisley shape.

2 From the center of the circle, draw a faint line of dots running in the direction where you want the tail of the paisley to be. The line should extend beyond the circumference of the circle by approximately the radius of the circle.

3 Draw a smooth curving line of dots from the bottom of the circle around to the tip of the tail. Dot another curve from the top of the circle around to the tail tip.

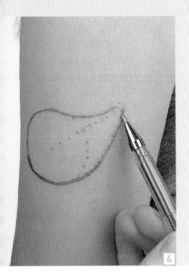

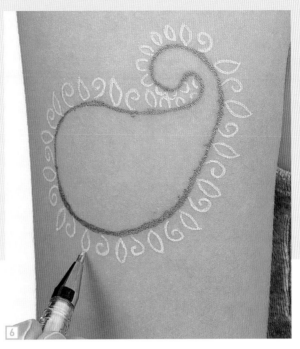

4 Join up the dots when you are happy with the shape. Wipe away the guideline of dots and the unwanted section of the main circle from inside the paisley shape.

6 There are many different ways to customize your paisley motif. Here, we have decorated the outside of the shape with small curls and leaves. Make them larger around the main part of the paisley and slightly smaller around the tail.

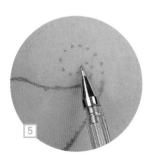

5 Dot out the shape of the paisley tail so that it curves around toward the main circle area.

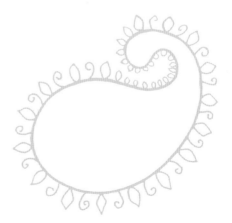

Dolphin and Fish

THE DOLPHIN IS ONE OF THE BEST-LOVED SEA MAMMALS AND APPEARS ON JEWELRY, CLOTHING, TEXTILES, AND TATTOOS. SIMILAR TO THE PAISLEY SHAPE, THE BODY OF THE DOLPHIN IS FORMED FROM A CIRCLE WITH A TAIL STEMMING FROM IT. BY VARYING THE SHAPE OF THE TAIL AND FINS, YOU CAN EASILY TURN THE DOLPHIN INTO A FISH. A SINGLE DOLPHIN OR FISH LOOKS GOOD ON THE ARM OR ANKLE, WHILE A PAIR LOOK GREAT AROUND A BELLY BUTTON. YOU CAN POSITION THEM SO THAT THEY APPEAR TO BE LEAPING IN THE AIR OR DIVING BACK INTO THE SEA.

DOLPHIN

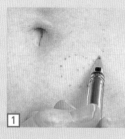

2 Draw a smooth curving line of dots from the bottom of the circle to the tip of the tail and another curve from the top of the circle to the tail tip.

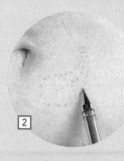

1 Dot out a circle (see page 16–17). It needs to be a reasonably large circle from which the tail can grow. From the center of the circle, draw a line of dots running in the direction where you want the dolphin's tail to be. The line should extend beyond the circumference of the circle by approximately the diameter of the circle.

3 When you are happy with your lines of dots, join them in two continuous curves. Wipe away any leftover dots to leave only the outline of the dolphin.

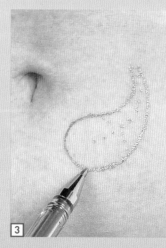

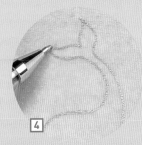

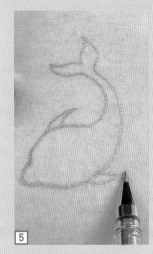

5 Add two fins and a rounded nose, again dotting out the shapes if you don't feel confident drawing them freehand. Wipe away the section of the circle where the nose adjoins.

4 Draw two curving lines to form the outside of the tail and a V shape to finish it off in the middle. Dot out the shapes first if you need to.

FISH

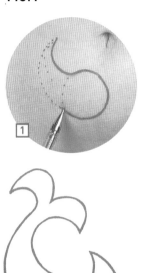

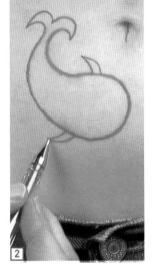

1 Use the same technique to draw the body of a fish, wiping away any leftover dots when you are happy with the shape.

2 Add the tail and fins, altering the shape from the dolphin design as shown.

Star

STARS ARE DISTINCTIVE AND APPEALING SHAPES AND WORK VERY WELL AS
TATTOOS. YOU CAN MAKE THEM ANY SIZE YOU WISH AND CAN CHANGE THE
NUMBER OF POINTS TO CREATE DIFFERENT SHAPES.
THIS STAR HAS THE STANDARD FIVE POINTS AND IS SIMPLE
TO DRAW ONCE YOU LEARN THE SECRETS OF ACHIEVING
SYMMETRY. THE FINAL DESIGN CAN BE FILLED WITH A SOLID BLOCK OF
COLOR OR WITH A MULTITUDE OF SMALL STARS TO CREATE A STUNNING MOTIF.
YOU COULD ALSO EMBELLISH YOUR STAR WITH CURLS AND SPIRALS.

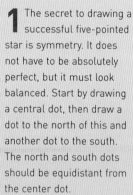

1 The secret to drawing a successful five-pointed star is symmetry. It does not have to be absolutely perfect, but it must look balanced. Start by drawing a central dot, then draw a dot to the north of this and another dot to the south. The north and south dots should be equidistant from the center dot.

2 Draw two equidistant dots to the east and west of the central dot. These dots should be the same distance from the center as the north and south dots.

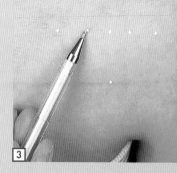

3 Now dot a point between the east dot and the center dot. It should be a little less than halfway out from the center dot. Draw another dot between the west dot and the center.

4 Draw a dot halfway between the east dot and the south dot, and another one halfway between the west dot and the south dot.

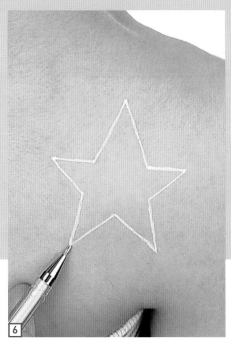

6 Join up the dots with straight lines to form a balanced star. Wipe away the remaining center dot.

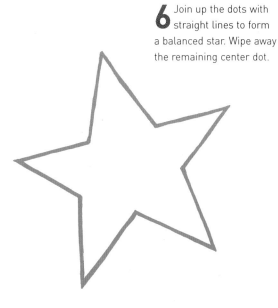

5 Dot two equidistant points below and to either side of the south point of the star. These two dots will form the two bottom points of the star.

CELTIC KNOT

CELTIC KNOTS ARE EXTREMELY EFFECTIVE AS BODY ART AND WORK WELL ON ALL AREAS OF THE BODY. ALTHOUGH KNOTWORK IS COMPLEX, IT CAN BE DRAWN EASILY ONCE YOU HAVE MASTERED THE BASIC PRINCIPLES. IT IS IMPORTANT THAT THE LINES OF THE KNOT OVERLAP EACH OTHER CORRECTLY SO THAT THE KNOT LOOKS AS IF IT IS FORMED FROM ONE CONTINUOUS LINE. ALTHOUGH THIS MOTIF IS A RELATIVELY SIMPLE EXAMPLE OF A CELTIC KNOT, YOU MUST STILL DOT OUT THE DESIGN FIRST IF YOU ARE TO ACHIEVE A BALANCED RESULT.

1 Draw a central dot where you want the knot to be. Draw another dot to the north of the central one, another to the southeast, and another to the southwest. They should be equidistant from the central dot.

2 Draw a small triangle around the central dot with the tip facing down. Do not make it too big.

3 Draw a line of dots that curves down from the north dot, passes around the left edge of the small triangle, and finishes at the southeast dot.

4 Dot out another curved line from the north dot, around the right edge of the small triangle, and down to the southwest dot.

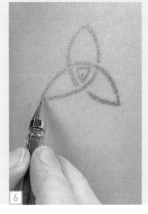

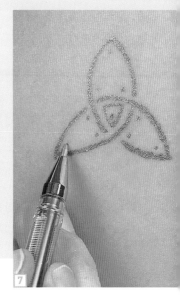

6 Join up the dots with smooth lines, but leave gaps where the curves overlap, as shown. Don't worry if you make a mistake. Simply wipe it off and start again.

7 Dot out the corner points of three triangles within the three outer knot elements, then join up the dots with curved lines.

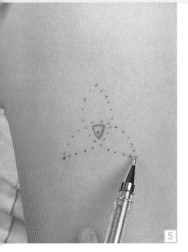

5 Draw the final curve from the southwest dot, over the top edge of the small triangle, and over to the southeast dot.

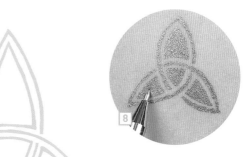

8 Fill all four triangular shapes with color.

Celtic Band

THIS LOVELY KNOTWORK BAND IS PERFECT AROUND AN ARM OR ANKLE AND CAN ALSO BE USED TO EMBELLISH OTHER DESIGNS, SUCH AS A YIN/YANG, SUN, OR HEART MOTIF. KNOTWORK NEEDS TO BE BALANCED TO LOOK GOOD, BUT YOU CAN GET THIS DESIGN RIGHT USING THE DOT TECHNIQUE, JUST AS YOU DID WITH THE CELTIC KNOT. THE ESSENTIAL THING IS TO MAKE SURE THAT THE S SHAPES ARE SYMMETRICAL. YOU CAN EMBELLISH THE BAND WITH CROSSES AND DASHES AS SHOWN HERE, CHOOSE DIFFERENT MOTIFS, OR LEAVE IT UNADORNED.

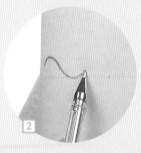

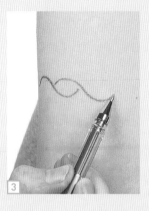

1 Draw a central dot where you want the band to be. Draw a straight guideline of dots outward in both directions from this point.

2 Starting at one end of the guideline, draw a flowing S shape. Dot out the shape first if you need to. The S should cross the guideline so that there is an even, rounded curve above and below the line.

3 Place your pen near (but not touching) the center of this first S shape. Draw another S shape from that point in the same way as before. Check that the two S shapes are of similar size and length.

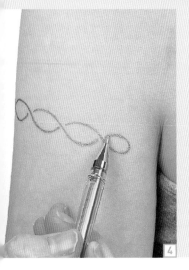

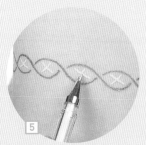

5 Draw a cross inside the S shapes in a second color. Make sure they do not touch any other lines. Draw a small curl in the spaces at each end of the band.

6 Draw small dashes outward from the tops and bottoms of the S shapes in another color. These can be as long or as short as you wish.

4 Repeat this process along the length of the band, using as many dots as you need to position the curves until you are confident the balance is right and you can smoothly fill in the lines. Extend each end of the band in a smooth curve back toward the guideline.

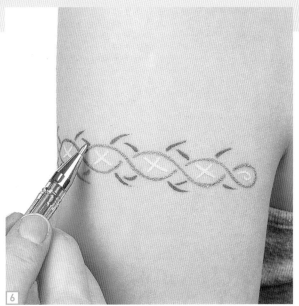

Oriental Calligraphy

ORIENTAL WRITING IS ENDLESSLY FASCINATING—THE WORD SYMBOLS LOOK LIKE PATTERNS AND WORK VERY WELL AS TATTOOS. THEY CONSIST OF A SERIES OF LINES THAT ARE FILLED OUT TO LOOK LIKE THEY HAVE BEEN DRAWN WITH A CALLIGRAPHY PEN. YOU CAN MAKE THEM AS SMOOTH OR AS JAGGED AS YOU WISH. THIS EXAMPLE IS MADE UP OF THREE JAPANESE SYMBOLS THAT MEAN ANGEL, BUT YOU COULD LOOK IN A JAPANESE DICTIONARY FOR ALTERNATIVES. YOU COULD CHOOSE A SYMBOL THAT HAS A SPECIAL MEANING OR ONE THAT SIMPLY LOOKS INTERESTING.

1 Draw lines of dots for each of the four lines of the left-hand symbol.

2 When you are satisfied with the result, join up the dots smoothly. Widen the lines to make them look more like calligraphy. Taper some of them to a fine point and make others flatter at the ends.

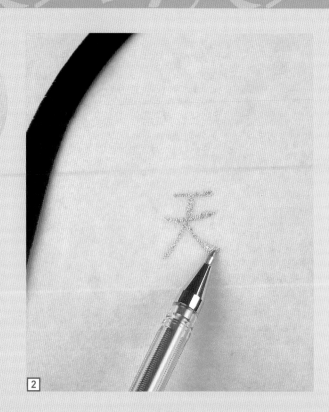

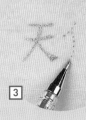

3 Dot out the two lines of the middle symbol, then smoothly join the dots. Fill out the lines as before.

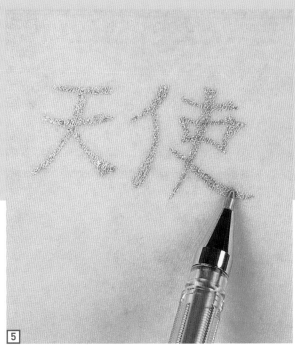

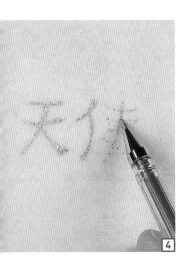

5 Fill in the lines and flatten or taper the ends until you are happy with the result. It is not important to get each line perfect because it is just the basic shape that matters. It is easy to make your lines too large when you first try to draw the symbols, but with practice you will get them smaller.

4 Dot out the seven lines of the right-hand symbol, then smoothly join the dots.

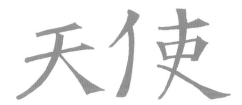

Hearts

HEARTS ARE THE UNIVERSAL SYMBOL OF LOVE AND LOOK GREAT AS TATTOOS. ALTHOUGH THE SHAPE APPEARS SIMPLE, IT CAN SOMETIMES BE DIFFICULT TO DRAW BECAUSE IT HAS TO BE SYMMETRICAL TO LOOK RIGHT. FILL YOUR DESIGN WITH ONE BLOCK OF COLOR OR USE MANY HEARTS INSIDE ONE ANOTHER. YOU COULD SURROUND YOUR HEART WITH LEAVES AND PATTERNS TO CREATE A MORE ELABORATE DESIGN, OR DRAW A STRING OF HEARTS AS AN ARM OR ANKLE BAND. YOU CAN ALSO ADAPT THE BASIC HEART TO LOOK MORE LIKE A PETAL OR LEAF SHAPE.

BASIC HEART

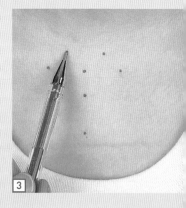

1 Draw a dot where the center of the heart will be. Draw another dot to the north of the central one. Draw another dot south of the central one, but position it about double the distance away than the north dot.

2 Draw two equidistant dots to the east and west of the north dot. These mark the widest part of the heart.

3 To mark the upper curves of the heart, place two equidistant dots between the north and east dots and the north and west dots. Position them slightly higher than the existing dots. This distance will determine how high and round the curved edges of your heart will be.

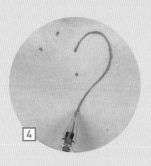

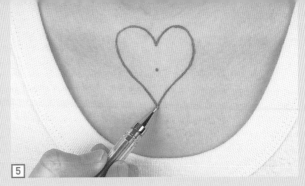

4 Join the dots for one side of the heart, starting from north dot and curving around and down to the south dot.

5 Repeat this process for the second side of the heart, making it as symmetrical as possible. If you do not feel confident about drawing a smooth line in one go, you can add more dots first. Wipe away the central dot when you have finished.

PETAL HEARt

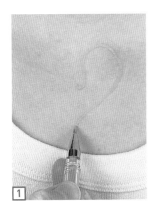

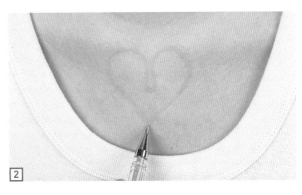

2 Repeat for the other side, again starting at the central dot.

1 Dot out a basic heart shape. Join the dots for one side in the same way as before, but start at the central dot instead of the north dot and create a smooth curve instead of a sharp point in this position.

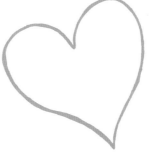

Hawaiian Flower

HAWAII IS A BEAUTIFUL ISLAND RENOWNED FOR ITS ABUNDANCE OF TROPICAL FLOWERS. THEY ARE A SYMBOL OF THE ISLAND AND ARE USED TO GARLAND VISITORS AROUND THEIR NECKS AND HEADS. THE BASIC SHAPE SHOWN HERE CAN BE MODIFIED OR EXPANDED TO CREATE A WHOLE RANGE OF EXCITING TATTOOS FOR THE BODY. YOU CAN DRAW ARMBANDS, ANKLE BANDS, OR EVEN BELLY BUTTON DESIGNS WITH THIS SIMPLE BUT EFFECTIVE FLOWER. IT LOOKS GREAT IN ONE COLOR OR IN COMBINATIONS OF TWO OR THREE.

1 Draw the central circle of the flower and fill it with color (see pages 16–17). Draw a second circle around the first one in a different color.

2 The petals of this flower are not symmetrical, so it is important that you draw dots where you want the tips of the petals to be. You will need about four or five petals, depending on how wide each one is. Use a third color for the petals.

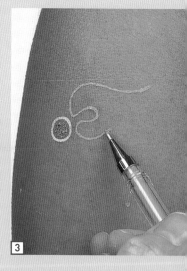

3 Each petal is an inverted heart (see page 55) and can be slimmer or wider, depending on where you position them.

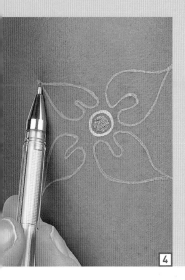

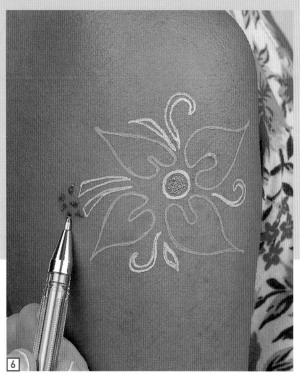

4 Always start at the top of each heart and draw out to the tips. It does not matter if the petals are irregular because this will make the flower look more natural.

6 Draw some small dots at the ends of the stamens, using the same color as the center circle of the flower.

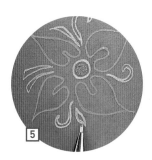

5 Add curls and leaves between the petals (see pages 26–27) and a couple of slightly curved shapes for the stamens.

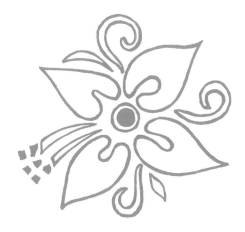

Butterfly

THE BUTTERFLY IS COLORFUL AND FLAMBOYANT AND LOOKS FANTASTIC AS A TATTOO. YOU CAN PUT IT IN MANY PLACES ON THE BODY, SUCH AS THE BASE OF THE SPINE, TOP OF THE ARM, OR ON THE ANKLE. YOU CAN MAKE IT SMALL AND DAINTY OR LARGE AND DRAMATIC. IT IS SIMILAR TO THE HEART OR STAR IN THAT IT MUST BE SYMMETRICAL TO LOOK GOOD. YOU CAN FILL THE BUTTERFLY'S WINGS WITH ANY PATTERNS YOU LIKE AS LONG AS EACH SIDE MATCHES. THERE ARE THREE SETS OF WINGS IN THIS EXAMPLE, BUT YOU NEED ONLY DO TWO OR EVEN ONE IF YOU FIND THAT EASIER.

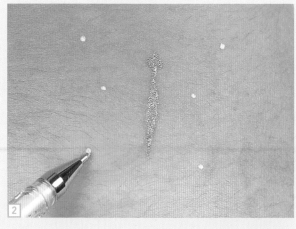

1 Draw a line of dots for the center of the butterfly's body. Don't make it too long because the wings need to extend above and below the body. Draw an outline of dots for the head and body, then join up the dots and color in the shape when you are satisfied.

2 Draw two dots to the right and left of the head to mark the tip of the top wings. They should be higher than the head and equidistant from it. Draw two more equidistant dots halfway down the body to mark the outer edge of the middle wings. Draw another two equidistant dots for the tips of the bottom wings. Make sure they are positioned slightly below the base of the butterfly's body.

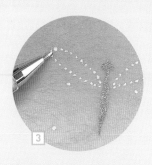

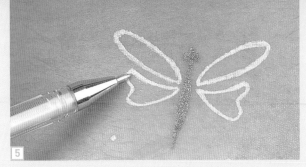

3 Using the top two dots as guides, dot out the shape of the top two wings, forming a smooth curve back to the body.

5 Dot out the shape of the middle wings, then join the dots with smooth lines. Note the different shapes of each pair of wings.

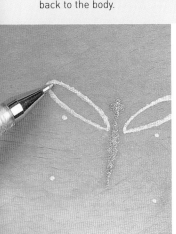

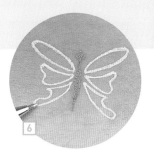

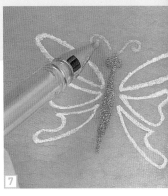

6 Repeat this process to draw the bottom pair of wings, making sure that they are as symmetrical as possible.

7 Add antennae to the head of the butterfly.

4 Join the dots with smooth lines when you are happy with the result.

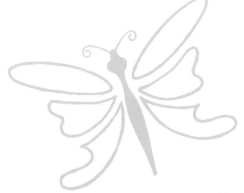

COMPLETE
DESIGNS

THIS CHAPTER FEATURES

25 DIFFERENT WAYS OF COMBINING THE

KEY ELEMENTS, WITH GUIDANCE ON HOW TO

CONSTRUCT THEM IF YOU ARE DRAWING THEM

FREEHAND AS WELL AS TEMPLATES THAT YOU CAN

TRACE. THERE IS ADVICE ON WHERE THE TATTOOS WILL

LOOK BEST ON THE BODY, ALTHOUGH MOST OF THEM

CAN EASILY BE ADAPTED FOR USE ANYWHERE. YOU

CAN COPY THEM EXACTLY OR EXPERIMENT WITH

YOUR OWN COMBINATIONS—THE

CHOICE IS YOURS.

KEY ELEMENTS
Circles and ovals, pages 16–17 • Curls and leaves, pages 26–29
Mystical eye, pages 34–35 • Star, pages 46–47

Man in the Moon

BODY SITES
• Shoulder
• Arm
• Hip

THE MOON is a powerful symbol and works well as a tattoo. This design features a crescent moon enclosed within a circle and surrounded by stars. The mystical eye is incorporated into the face of the moon. Start by drawing a circle, then draw the outline of the crescent moon within it. Notice that the base of the crescent ends in a spike and a curl. Next, draw the lips, eye, and a small star on the cheek. Draw the outlines of the three stars on the other side of the crescent moon; one of these is only half a star. Asymmetrical stars are used here, but you could draw symmetrical ones if you prefer. Finally, color the stars, face, and sky. Use a darker color for the sky and a lighter color for the face and stars to provide a strong contrast. If you wish, add some glitter to the face and stars for a dazzling effect.

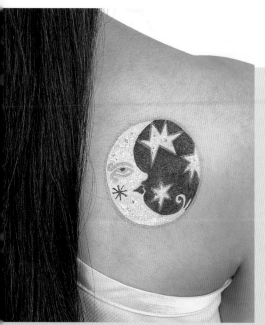

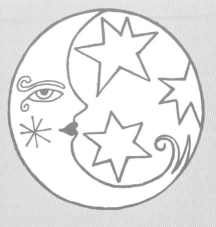

KEY ELEMENTS
Retro flowers, pages 30–31 • Snake, pages 36–37

Sinuous Snake

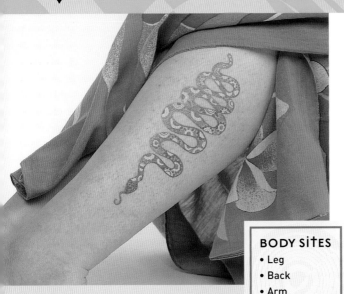

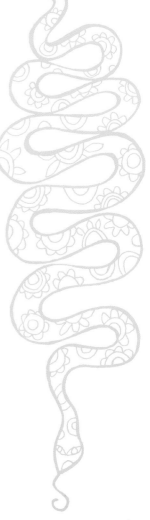

BODY SITES
- Leg
- Back
- Arm

THE SINUOUS curves of a snake are ideal for tattoos, and the floral decoration in this design makes the snake anything but sinister. The example shown here is quite large, but you can adapt it to fit onto smaller body parts by drawing fewer curves. Remember to make the snake's body thick enough to accommodate the decoration, though. Start by dotting out and drawing the outline of the snake, making it as long or short as you wish. Don't forget the eyes and tongue. Fill the inside of the snake with a variety of retro flowers. Notice how most of the flowers are only partially visible where they touch the outline of the snake. Fill the rest of the snake's body with blocks and dots of color.

KEY ELEMENTS
Sunshine rays, pages 20–21 • Retro flowers, pages 30–31
Dolphin and fish, pages 44–45

LEAPING FISH

<div style="border: 1px solid; padding: 10px;">

BODY SITES
- Ankle
- Shoulder
- Arm

</div>

THIS LITTLE FISH can be used on its own, as shown here, or you can draw a pair of fish like for the Diving Dolphins opposite. Start by drawing the outline of the fish, then add the eye. The eye is composed of a retro flower enclosed within a circle surrounded by sunshine rays. The rays are so small that you can easily draw them freehand, but if you are drawing a bigger fish, you may want to use the dot technique to position the rays symmetrically around the circle. Next, draw the outline of the mouth and divide the body into sections. Fill each section of the body with different designs for the scales of the fish. Here, zigzags, curves, and patterns of lines have been used. Fill the different areas of the fish with the colors of your choice. Bright greens and blues are especially effective for fish, and metallic colors work particularly well.

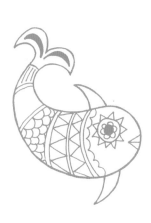

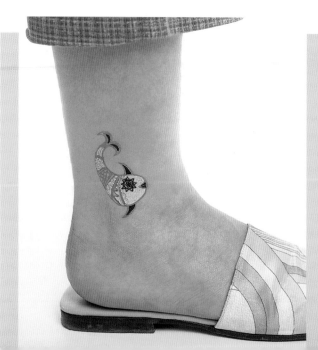

KEY ELEMENTS
Curls and leaves, pages 26–29 • Dolphin and fish, pages 44–45

DIVING DOLPHINS

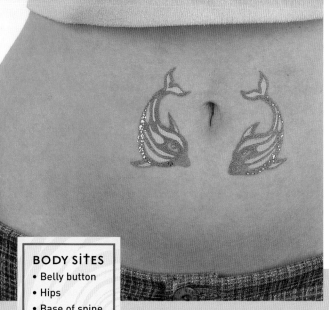

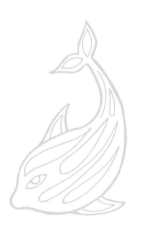

BODY SITES
- Belly button
- Hips
- Base of spine
- Shoulders

DOLPHINS ARE universally popular symbols. A single dolphin would look good on its own, but you can create an even more dramatic effect by drawing a pair together. It is important to make the dolphins as symmetrical as possible, so although you can use the dot technique to draw them if you wish, you may find it easier to use the transfer method to draw the outlines. Take care when placing the tracing paper onto the skin that the dolphins are level with each other and not askew. When you are satisfied with the outlines, add the shapes on the bodies. Again, try to make them symmetrical. They don't have to be exact, but they do need to look balanced. The shapes used here are drawn in the same way as leaves, using different curved outlines. Color the dolphins and add the eyes. You might also like to add some glitter to give them a more slippery look.

KEY ELEMENTS
Circles and ovals, pages 16–17 • Sunshine rays, pages 20–21
Curls and leaves, pages 26–29

Smiling Sun

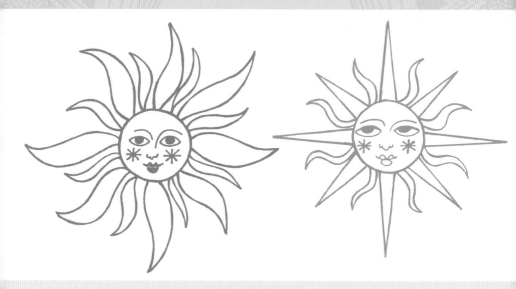

BODY SITES

- Arm
- Shoulder
- Necklace area
- Hip
- Ankle

A SUN DECORATED with the face of a smiling woman is a very popular and attractive tattoo. Start by drawing a circle that is large enough to accommodate a face and check that you have enough room around the circle for the rays. Draw the eyes and eyebrows, making sure they are well balanced. Draw the curves of the nose and mouth, then add two small circles for the top lip and an oval for the bottom lip. Draw a pair of stars on the cheeks. Decide which ray design you prefer. The tattoo on the right uses a symmetrical combination of straight and curved rays; notice that the curved rays are slightly shorter than the straight rays.

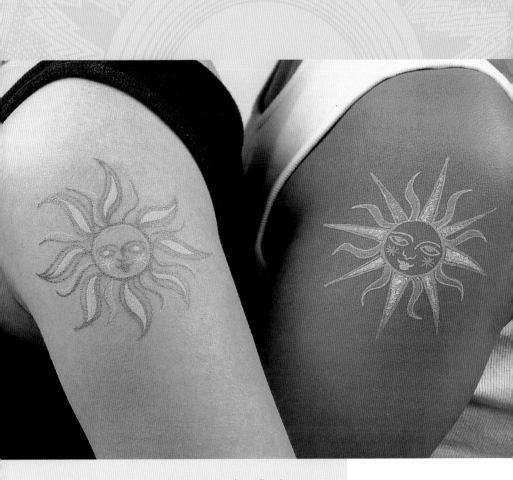

Alternately, you may prefer the more free-flowing design on the left. These rays are drawn in the same way as you would drawn leaves. Notice that the larger rays have a smaller ray drawn inside, which gives them a fuller effect when colored.

PROUD PEACOCK

BODY SITES
- Hip
- Shoulder
- Arm
- Base of spine

THIS TATTOO evolves from two interlocking paisley shapes. Draw the large paisley shape first to form the peacock's tail and wing, then add the smaller paisley to form the body and head. Take your time getting the outline of your peacock in proportion, carefully wiping away any unwanted dots and guidelines when you are satisfied. Define the wing area by drawing a line just inside the edge of the paisley, then do the same for the tail area. Add feathers inside the wing by drawing a series of overlapping curves. Do the same in the lower half of the tail area. Draw a heart inside the top of the tail with curving lines radiating outward from it.

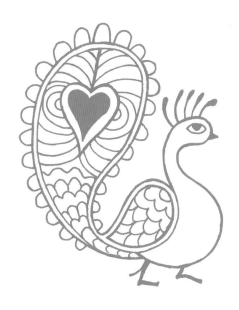

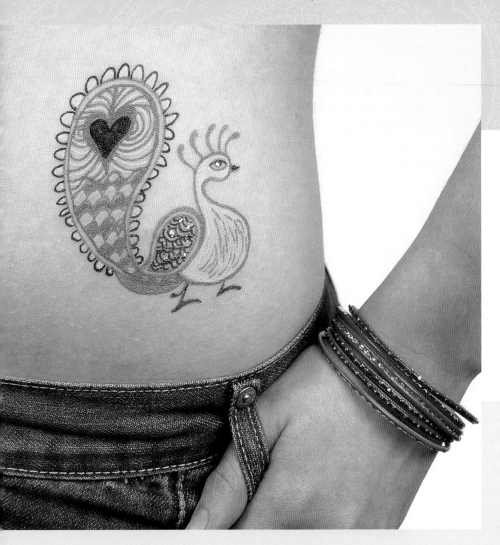

Draw a series of curves around the outside of the tail.
Finally, draw the bird's eye, beak, and legs and add
some curls to the top of its head. Color your peacock
in greens, blues, and purples. Metallic colors and
glitter are ideal for re-creating the iridescent feathers
for which peacocks are renowned.

PAISLEY BAND

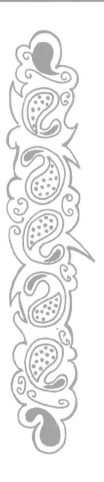

BODY SITES
- Wrist
- Ankle
- Arm

THIS WRISTBAND is composed of a series of paisley shapes. You will need to draw them quite small if you are using the band around a wrist or ankle, but you can make them a little larger if you are drawing them around an arm. Place a dot in the center where you want to draw the band. Starting at this point, draw a straight guideline of dots outward in both directions to help you draw the paisley shapes level with each other. Draw the paisley shapes, inverting alternate ones as shown. When you are satisfied that the band is level, wipe away any guide dots that remain visible. Fill each paisley with decoration, then draw some spirals around them. Draw a curved outline around the whole band design, mirroring the shapes inside it.

Starburst

BODY SITES
- Shoulder
- Hip
- Arm
- Necklace area

BASED ON designs from the 1970s, this star would not look out of place with platform boots and a miniskirt. It is built up using lines of different colors. Draw the outline of the main five-pointed star, then use a second color to draw the outline of a slightly smaller star inside the first one. Repeat this process with two more colors, drawing slightly smaller stars each time. Try to keep the space between each star's outline regular. Fill the central star with color. Now add the five points of another star radiating out from between the points of the first star you drew. Draw another outline within each of the points, then repeat this process again. Fill the central area of each point with color. It is a good idea to practice this design on paper first so that you can decide on the best color combinations to use. Add some glitter to the central motif for a final starry touch.

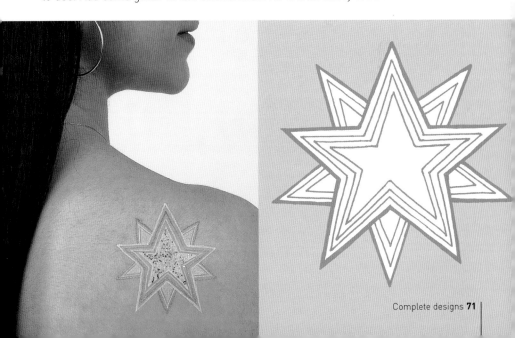

Finger Design

BODY SITES
- Hand
- Foot
- Wrist
- Ankle
- Arm

THIS TATTOO looks very effective running down a single finger, or you could spread the design down all the fingers. Start by drawing a spiral around the knuckle, then draw a curving line along the length of the finger, ending just below the nail. The curves of the line will become shallower as the finger becomes narrower. You can adapt this design into a horizontal band by making all of the curves the same depth. Draw a small retro flower within each curve of the line, then add small petals all along the line. Notice how the petals alternate from one side of the line to the other at the beginning and end of each curve. Although floral designs are ideal for use on the hands, shapes such as stars, hearts, and circles could be substituted for the flowers if you prefer.

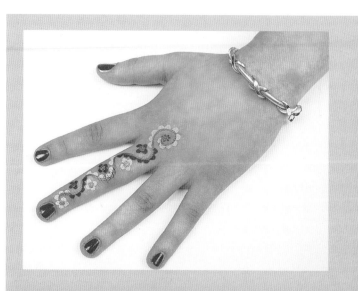

KEY ELEMENTS
Circles and ovals, pages 16–17 • Sunshine rays, pages 20–21
Vines and tendrils, pages 24–25

SEA ANEMONE

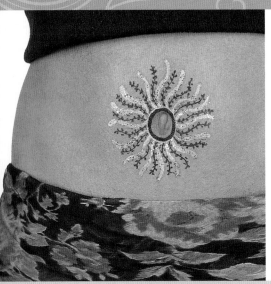

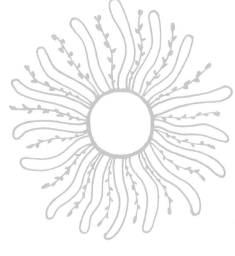

BODY SITES
- Belly button
- Arm
- Shoulder
- Ankle

THE INSPIRATION for this tattoo is the flowing, organic form of the sea anemone. It can be drawn in just two colors with a sprinkling of glitter, as shown here, or you could create a multicolored version. You might like to try it in greens and blues to reflect the colors of the sea. Draw the two central circles, adjusting their size to suit the location of the tattoo. Then add the 16 curving rays, positioning them symmetrically around the circles. They can all curve in slightly different directions, as if they are floating in water, but try to make them approximately the same length. Notice that the ends of the rays are round instead of pointed. Next, draw a vine emerging from between each of the rays. You should have 16 vines altogether, and these can also curve in slightly different directions. If you have not drawn the design around a belly button, color the central circle.

KEY ELEMENTS
Circles and ovals, pages 16–17 • Butterfly, pages 58–59

BEAUTIFUL BUTTERFLY

BODY SITES
- Hip
- Arm
- Shoulder
- Ankle

BUTTERFLIES ARE very popular as tattoos because of their pretty wings. You can vary the shapes of the wings in any way you like, but make the top wings larger than the lower ones. You can embellish the wings with a variety of different designs, including lines, dots, curls, or even squares. Always make the wings and their decoration symmetrical. Two examples are shown here. The butterfly pictured below has a retro feel to it, with just a single pair of wings decorated with teardrop shapes within teardrops.

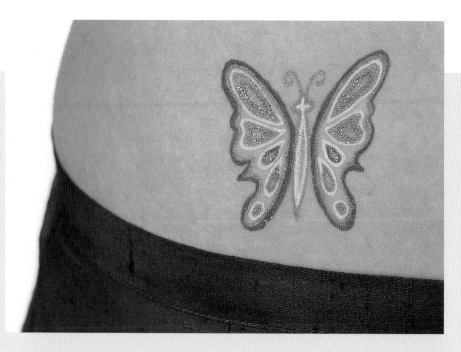

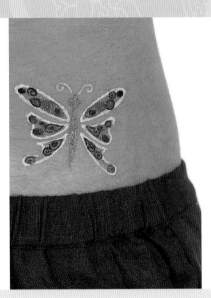

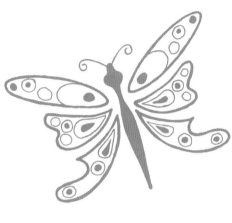

Draw the outline of the butterfly, then draw another line around the inside of the wings. Draw the teardrop shapes next, which are simply pointed oval shapes. Add a series of inner lines within the teardrops in different colors until the whole design is filled. The design pictured above has three pairs of wings filled with circles, dots, and ovals. Draw the outline of the butterfly first, then add the wing decoration.

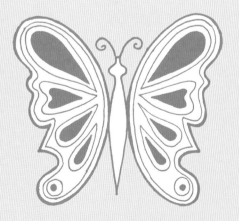

Hawaiian Band

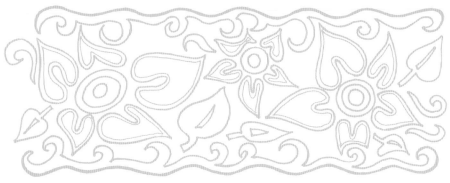

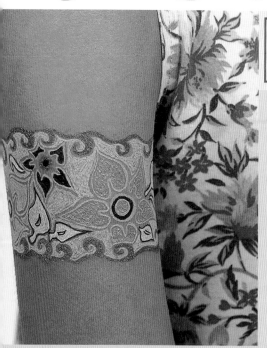

BODY SITES
• Arm

THIS BAND features three Hawaiian flowers. Draw a guideline of dots for the top and bottom of the band. Draw a curving stem along each of the lines, adding small curls along the stems facing inward. Draw three flowers between the stems, adjusting the size and position of the petals to fit comfortably in the space you have. Add some leaves around the flowers so that the spaces are filled in a balanced way. Fill the design with lots of colors.

KEY ELEMENTS
Curls and leaves, pages 26–29 • Hawaiian flower, pages 56–57

Hawaiian Motif

THIS MOTIF consists of a Hawaiian flower embellished with curls, leaves, and dots. Draw the central circles first and surround them with small dots of color. Add the five petals, spacing them evenly around the circles. These petals are ideal shapes for practicing your freehand drawing because they do not have to be exactly the same shapes and sizes. Surround the flower with a balanced arrangement of curls, leaves, and dots. This tattoo looks best in natural floral colors, such as pinks for the flower and greens for the leaves. Add a dusting of glitter to the flower to make it sparkle within its bed of foliage.

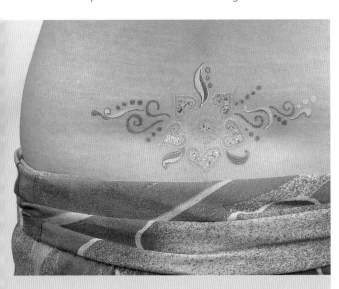

BODY SITES
• Base of spine
• Nape of neck

KEY ELEMENTS
Circles and ovals, pages 16–17 • Sunshine rays, pages 20–21
Oriental calligraphy, pages 52–53

JAPANESE SYMBOL

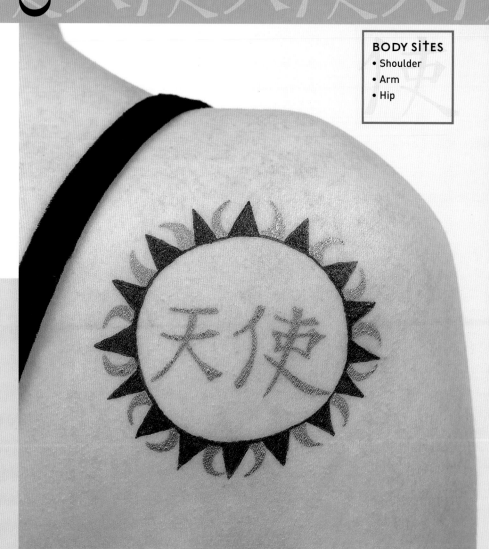

BODY SITES
• Shoulder
• Arm
• Hip

THIS JAPANESE SYMBOL means "angel" and is surrounded by a circle of sunshine rays. You will need a fairly large area for this design because the word is composed of three separate characters. Draw the circle first, making sure it is large enough to accommodate the calligraphy inside. Check this by dotting out the shapes of the characters, making sure that they are positioned centrally within the circle. Make any adjustments that are necessary, then refine the lines of the calligraphy. Draw the pointed rays next, starting with the north, south, east, and west rays, then adding the northeast, southeast, northwest, and southwest rays. Draw another straight ray between each of the existing ones, then add a curved ray between each pair of straight rays. You should have 16 straight rays and 16 curved rays when you are finished. This design looks particularly good when drawn in just a couple of strong colors.

PAISLEY PUSSYCAT

BODY SITES
- Nape of neck
- Arm
- Base of spine
- Lower leg

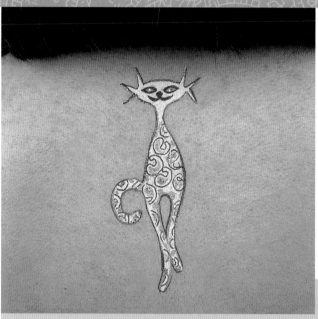

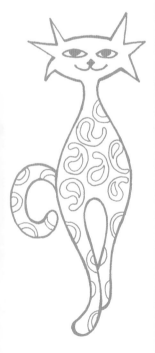

THIS CAT HAS a mischievous face and its body is filled with paisley shapes. Start by dotting out two oval shapes for the cat's head and body, adding guide dots for a thin neck and a pair of long legs. Draw a dot where the end points of the ears and whiskers will go. When you are happy with the result, join up the dots of the head, body, and tail, wiping away any leftover guide dots when you are finished. Add the eyes, nose, and mouth, then fill the body with paisley shapes. Notice how some of the paisleys are only visible as half circles on narrow areas. Color the cat and add a little glitter if you wish, making sure you add a glint to the eyes.

KEY ELEMENTS
Circles and ovals, pages 16–17 • Vines and tendrils, pages 24–25
Curls and leaves, pages 26–29

CURLING FIREBALL

DIFFERENT SHAPES and sizes of curls radiating out from a circle like flames produce this striking design. Draw the circle first and then add curls around it. Draw tiny shoots of berries around the inside of the circle, then add some more around the outside of the curls. Add some outlines around the curls as shadows and highlights. In the picture below you will see a matching wristband. This is the vines and tendrils key element and is a great way of mixing and matching tattoos in the same way that you would combine jewelry.

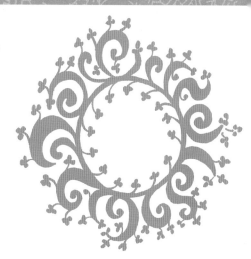

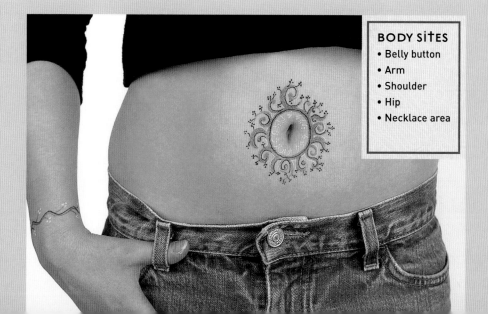

BODY SITES
• Belly button
• Arm
• Shoulder
• Hip
• Necklace area

KEY ELEMENTS
**Curls and leaves, pages 26–29 • Celtic knot, pages 48–49
Celtic band, pages 50–51**

CELTIC KNOTWORK

BODY SITES
- Arm
- Ankle
- Wrist
- Shoulder
- Belly button

CELTIC DESIGNS are beautiful and need not be difficult if you know the drawing techniques. The design pictured below combines the basic Celtic knot key element with a more elaborate version of the Celtic band element. Draw the knot first, making sure that you position it centrally, and decorate it with small dots. Add the band beneath, drawing the line of S shapes first and then the decoration of curls. The tattoo shown opposite features a modern interpretation of the Celtic knot and looks great combined with a simple band of stripes. Draw the outline of the

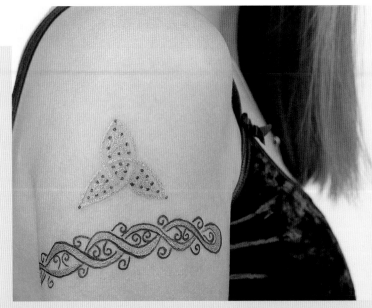

knot first, this time rounding the ends instead of making them pointed. Fill the knot with lines of different colors. The band of stripes can be as narrow or wide as you wish. Start each stripe by drawing a guideline of dots. When you are satisfied that they are level, join up the dots and widen the stripes. It looks effective if you make each stripe a different size, rather like a barcode. Echo the colors of the knot in the band. You don't have to use the knot and band together—you could draw the knot around a belly button and the band around the wrist, for example.

Mendhi Motif

BODY SITES
• Shoulder
• Arm
• Belly button
• Base of spine

THIS MOTIF combines an Indian mendhi flower with tendrils of spiral shapes. Tendrils of leaves would also work well. Although you can draw the flower smaller if you wish, it is easier to add the tendrils to a larger flower. Start by drawing the outline of the mendhi flower. If you are drawing the motif around a belly button, omit the central circle. Try to make the petals symmetrical and of similar size, but don't worry about any small variations in the curves of the petals because this will simply enhance the effect of this organic design. Draw a curving line between each pair of petals, ending with a small spiral. Add more spirals along the length of each tendril. You can draw the spirals curling in different directions if you wish, but they look more natural when curling back toward the flower. Finish the tattoo by filling the flower with bright colors.

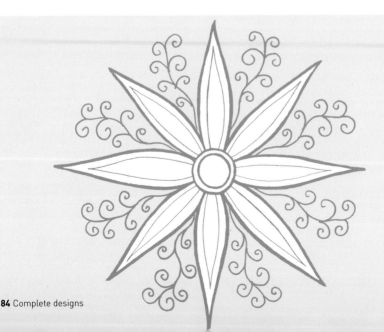

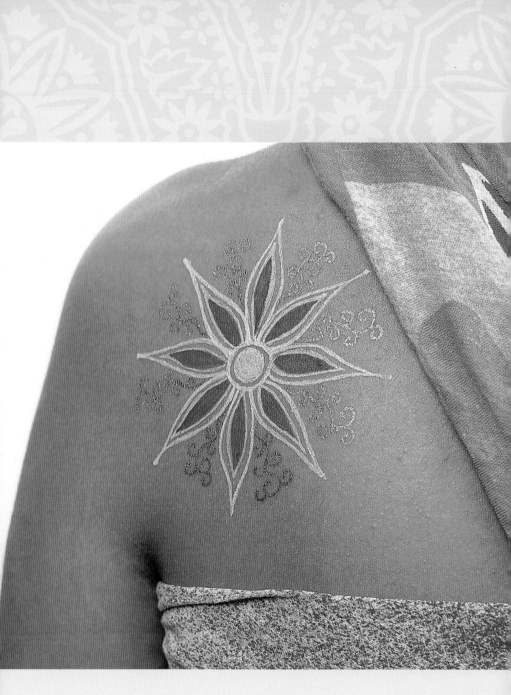

Mackintosh Spray

A SPRAY OF Mackintosh roses and leaves forms a pretty and delicate tattoo. It is important to position the largest rose centrally and to surround it with enough small roses and leaves to make a balanced design. Draw the central rose first, then add the three pairs of diamond-shaped leaves around it. Next, draw a small rose at each end where you want the band to finish. Fill the space between the central rose and the end points of the band with more roses and leaves. Make these leaves more curved than the others. You can draw all the roses in the same color or choose several different shades, but try to keep your use of colors symmetrical so that the finished design looks balanced.

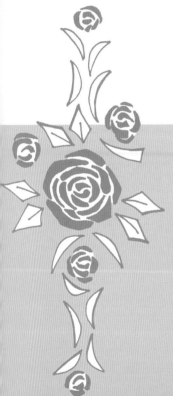

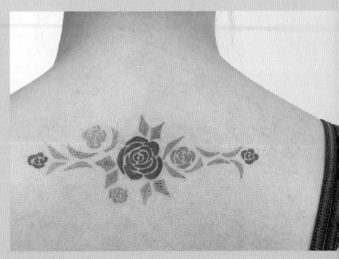

KEY ELEMENTS
Curls and leaves, pages 26–29 • Spirals, pages 38–41
Hearts, pages 54–55

HEART NECKLACE

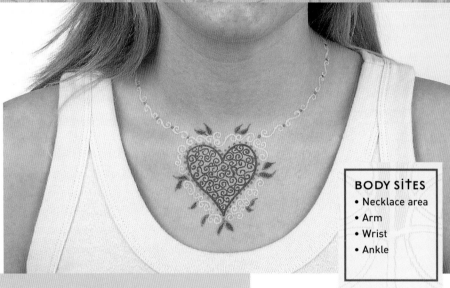

BODY SITES
- Necklace area
- Arm
- Wrist
- Ankle

YOU CAN ADAPT this pretty design for other areas of the body by altering the size of the heart and omitting the chain. Draw the heart first and fill it with a pale color. Draw some dots around the outside of the heart, then add some small spirals and leaves. Draw two guidelines of dots for the chain, making sure they are symmetrical. Draw an S-shaped spiral for each link in the chain, with a small dot between each spiral. Finally, fill the inside of the heart with small spirals of a darker color that will stand out from the pale background.

RETRO BOUQUET

BODY SITES
- Arm
- Back
- Leg

A BOUQUET OF retro flowers looks good on many areas of the body and should be drawn in lots of bright colors. You can copy each of the flowers shown here or design some new ones of your own. Start with the smallest flower at the base of the design, drawing a small circle for the flower head and a curving line for the stem. Add the petals and leaves. Draw the next flower just above the first one. Continue working up the design, drawing the third and then the fourth flowers.

The flower at the top should be the largest and have the most elaborate petal design. Notice how the stem of each flower curves in a new direction to give the impression that the flowers are growing upward.

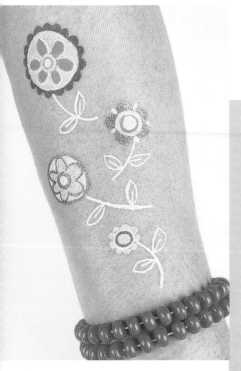

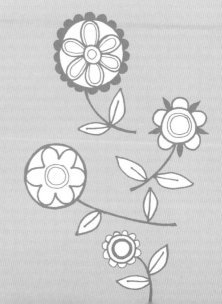

KEY ELEMENTS
Yin/yang symbol, pages 18–19 • Sunshine rays, pages 20–21
Curls and leaves, pages 26–29

Yin/yang Sun

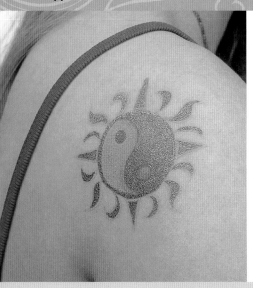

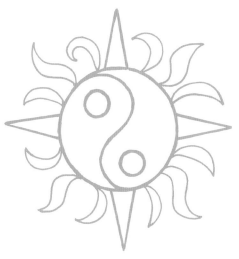

BODY SITES
- Shoulder
- Arm
- Hip
- Ankle

THE YIN/YANG SYMBOL is always popular as a tattoo and can be adapted into many different designs, such as this simple sun motif. Draw a circle and add the yin/yang design inside it. Next, add the sunshine rays. Draw a straight ray at the north, south, east, and west of the sun, then add a curved ray in the northeast, southeast, northwest, and southwest. Now draw a curl between each pair of rays. You should have a total of 16 rays and curls when you have finished, but you could vary this number as well as the combination of rays and curls if you wish. It is best to use only two colors for this tattoo because this is most effective for a yin/yang design. Although the example pictured here is quite large, you could easily reduce it for a more subtle result. You could also change the proportions, making the yin/yang symbol smaller and the rays and curls larger.

KEY ELEMENTS
Circles and ovals, pages 16–17 • Sunshine rays, pages 20–21
Curls and leaves, pages 26–29 • Hearts, pages 54–55

LOVE HEARTS

BODY SITES
• Belly button
• Arm
• Shoulder
• Base of spine

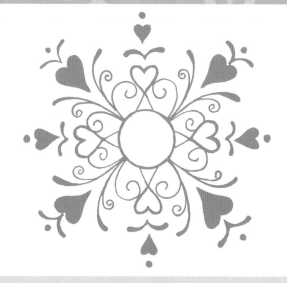

THIS IS A DELICATE and feminine design that looks best around the belly button. Make it smaller if you prefer by omitting the outer ring of hearts. It is important to keep the design symmetrical because any shapes that are the wrong size will alter the balance of the design. Draw the central circle, then add four small straight rays at the north, south, east, and west points. Draw a heart at the tip of each ray, making sure they are all the same size. The hearts in this design are quite small, so you will probably be able to draw them freehand. Draw a pair of curved lines above each heart, then add another heart above these with a dot above each one. Add two curls emerging from between each pair of rays. Build onto these by adding larger curls, then draw another heart between each pair of curls. Draw a pair of curved lines and a dot above each of these four hearts. Color the hearts and rays.

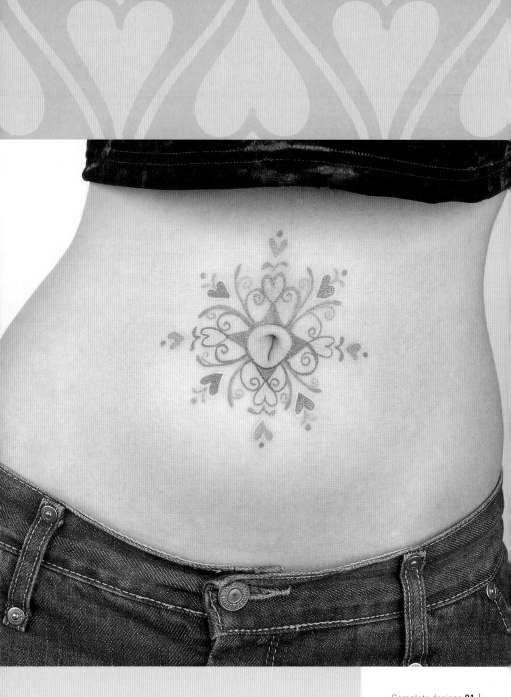

KEY ELEMENTS
Retro flowers, pages 30–31 • Mystical eye, pages 34–35

EGYPTIAN MOTIF

BODY SITES
- Ankle
- Arm
- Shoulder
- Hip

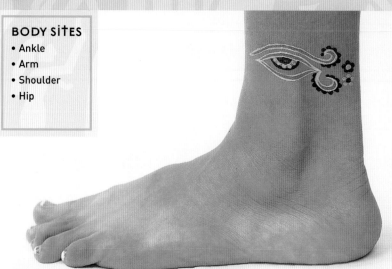

THE MYSTICAL EYE is a dramatic design that can be used as a single motif on most areas of the body. This example has been adorned with retro flowers and decorative petals to give it a more feminine touch. Start by dotting out the shape of the eye and eyebrow. When you are happy with the curves you have created, carefully join up the dots of the design with smooth lines. Draw the iris and pupil of the eye, making sure that you leave enough space for the petals to fit between them. Add a couple of small retro flowers at the outer edge of the eyebrow (just the flower heads, without any stalks or leaves), and draw some small retro-style petals along the curls at the edge of the eyebrow and eye.

Draw some more petals around the pupil of the eye. Color the outline of the eye and eyebrow.

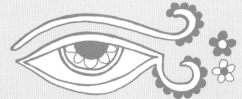

GEOMETRIC CHOKER

ZIGZAGS AND angular spirals are very simple to draw and create stunning tattoos. Start with a line of dots to indicate the top and bottom of the choker. Draw the two lines of zigzags next. Start by placing a dot where each point of the zigzags should go, then join up the dots with straight lines. Fill the space between the zigzags with angular spirals. These are small enough to draw freehand, but you can dot out the shape of the spirals first if you wish. Color the space between the zigzags and the top and bottom guidelines. Two colors have been used here, but you could draw each spiral in a different color for a psychedelic effect. Try adding some glitter for a glamorous finish.

BODY SITES
- Neck
- Arm
- Wrist
- Ankle

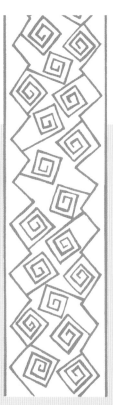

İndex

CREDITS

Quarto would like to thank Gina Blaxill, Rehma Chandaria,
Priscilla Divani, Katie Eke, Sophie Fleck, Holly Kosmin,
Laura Moriarty, and Valerie Voisey for modeling
the tattoos in this book.

All photographs and illustrations are the copyright of Quarto.

THE AUTHOR

Sophie Hayes (B.A. Hons) studied fashion with marketing. Since traveling to
India in 1998, she has been fascinated by the art of mendhi and body art
across the world. She now owns her own body art company and is involved in
all aspects of body art, including face painting, air brush, and henna art. She
has also written guides to henna body art and hair wrapping, and all of her
designs and products are available via her website, www.bodydeco.co.uk